seashells

abrams, new york

seashells

photographs by josie iselin *text by* sandy carlson

Editor: Nancy E. Cohen
Designer: Darilyn Lowe Carnes with E. Y. Lee
Production Manager: Alison Gervais

Library of Congress Cataloging-in-Publication Data

Iselin, Josie.
 Seashells / photographs by Josie Iselin ; text by Sandy Carlson.
 p. cm.
 ISBN-13: 978-0-8109-9327-3 (hardcover with jacket)
 ISBN-10: 0-8109-9327-9 (hardcover with jacket)
 1. Photography of shells. 2. Iselin, Josie. I. Carlson, Sandy. II.
Title.

 TR729.S54I84 2007
 779'.37092—dc22 2007003193

Printed and bound in China
10 9 8 7 6 5 4 3 2 1

HNA
harry n. abrams, inc.
a subsidiary of La Martinière Groupe

115 West 18th Street
New York, NY 10011
www.hnabooks.com

for my grandmother Fannie Brawley | JLI

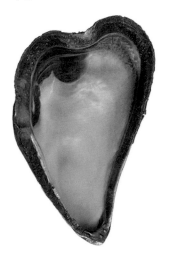

for my wonderful family—Steve, Zoe, Eli, and Saffron | SJC

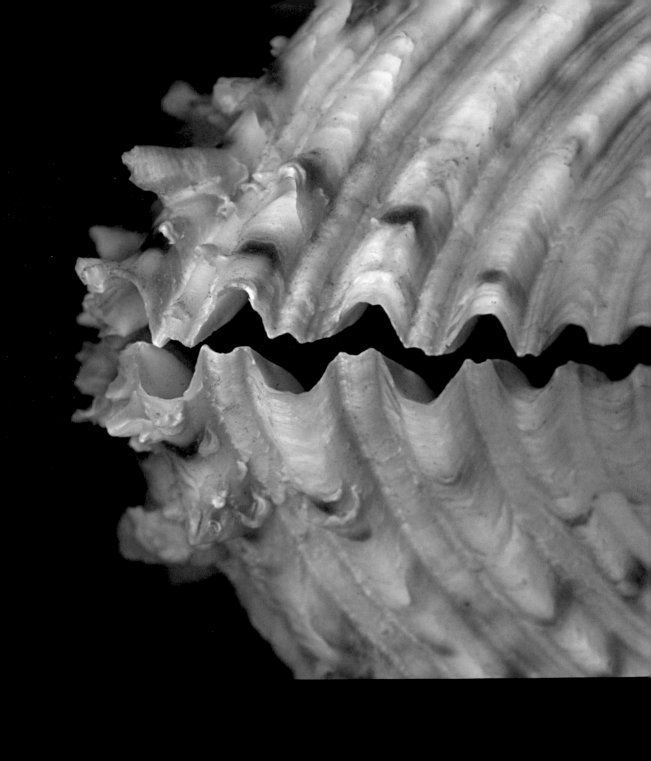

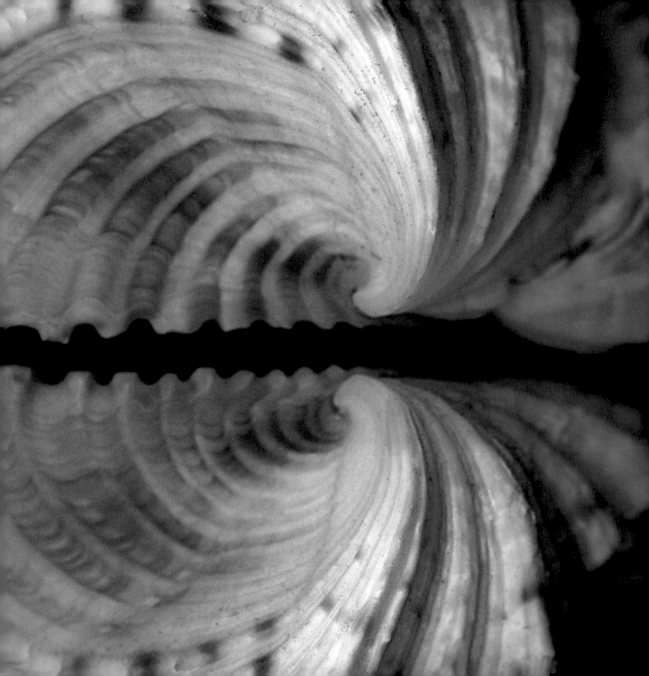

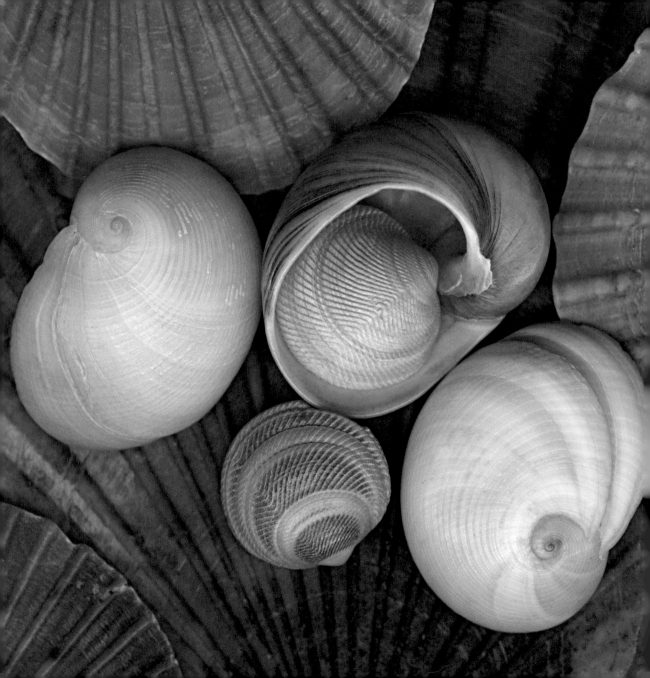

introduction

Washed from the ocean and scattered along the beach, seashells exert a pull on the imagination as strong as the tides. Intrigued, we pluck one up from the sand to trace its smooth curves, recesses, ribs, or spines, or hold it to an ear to hear the echoing sea.

Collected and coveted through the ages for the beauty of their forms and surface patterns, shells have stimulated the creativity of artists, architects, and designers across the globe. They are made into jewelry, woven into hair, and stitched onto clothing; they are used as money, in building materials, and as musical instruments. Shells' pure geometries—such as the elegant logarithmic spiral of the chambered *Nautilus*—have inspired wonder and provoked mathematical analysis at least since Aristotle's day.

Seashells offer glimpses of life in a vast underwater world that is largely foreign and inaccessible to us land dwellers. They offer marine animals some protection from predators and harsh environmental conditions; they also provide the rigid support that enables them to eat (and avoid being eaten), respire, move, and reproduce. The diverse forms, sizes, patterns, and colors of seashells reveal much about the behavior of the organisms that made them. A streamlined shell can help a clam burrow to safety in the sand or enable

a *Nautilus* to propel through the sea in search of prey. Abrasive ridges allow some species of clam to bore a home out of rock, while a sand dollar's tiny spines help it tilt edgewise in the sand as it gathers food.

Molluscs—as well known for seafood as for seashells—present beachcombers with the most abundant and familiar treasures. But as the photos in this book show, an astonishing range of ocean-dwelling organisms, including some types of algae, mineralizes shells, usually of calcium carbonate, from elements drawn from the sea. They generate a wide variety of forms, influenced not only by ancestry but also by environment, function, and growth rates.

Six phyla, or major groups, of marine animals appear in these pages, including five classes of mollusc—one of the largest groups in the animal kingdom, with more than one hundred fifty thousand species. Molluscs include gastropods (whelks, conchs, and other snails, as well as abalone and limpets), which have a single, usually spiraled, shell; bivalves (scallops, oysters, mussels, and other clams), with shells comprised of two parts, or valves; cephalopods (*Spirula*, nautiloids, ammonites), whose chambered shell coils into a flat spiral; scaphopods (tusk shells), whose tubular shell is open at both ends; and polyplacophorans (chitons), which have shells of eight overlapping plates. The other phyla illustrated here are echinoderms (sea urchins, sand dollars, sea

stars), characterized by spiny skin and fivefold radial symmetry; arthropods (barnacles), with segmented bodies; brachiopods (lamp shells), with two hinged valves; cnidarians (corals), tiny animals that tend to form colonies; and poriferans (sponges), primitive animals with no organs or tissues.

All are captivating, from exotic salmon-colored corals to the plainest white clam, and all harbor secrets. For all that we know about how seashells grow, function, and evolve, a surprisingly large number of questions remain unanswered, drawing us back to the sea, inviting both vigorous inquiry and simple awe.

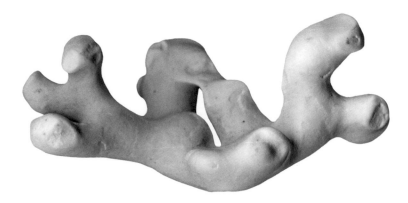

Jingle shells. Massachusetts. These translucent oyster shells are like small bits of summer. They clink and jingle when jostled together, giving rise to their common name, because they lack the chalky outer layer found in most other mollusc shells. The right valves are thin and fragile and seldom reach the beach before breaking into pieces; only left valves are pictured. The whitish scar on the interior marks where the oyster's three adductors—the muscles that hold the shell's two valves tightly together—attached to the shell.

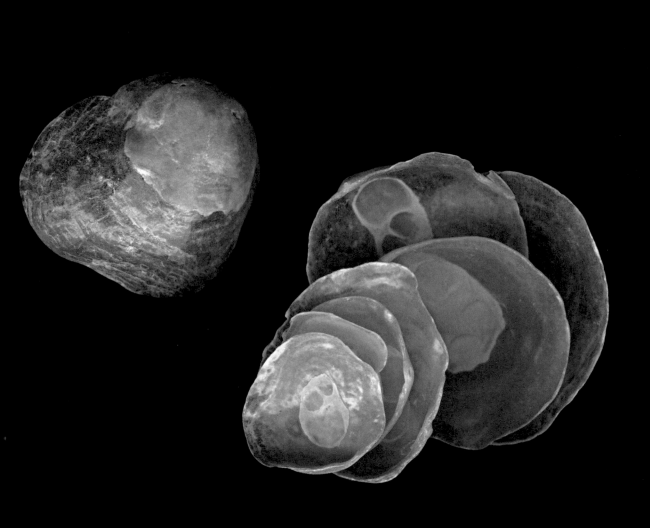

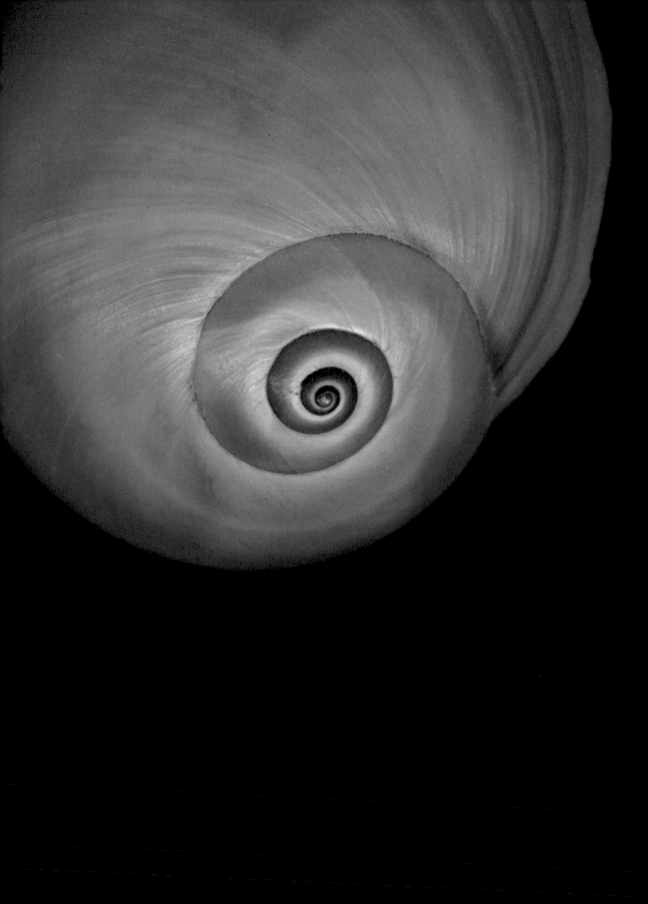

Opposite: **Naticid snail. Georgia.** Most molluscs, like this luminous moon snail, grow their shells in spiraling tubes. The outer surface of the tube grows more rapidly than the inner surface, generating seashells' wide variety of spiral shapes.

Following pages: **Snail opercula. Hawaii.** As comforting to rub as worry beads, these smoothly polished disks form on the foot of many species of snail. They mineralize separately from the shells, closely fitting the shape of the aperture, or shell opening, and growing along with it, to serve as a trap door. Like shells, opercula last long after the snail dies, each literally providing a footprint of the size and shape of the aperture at the end of the snail's life.

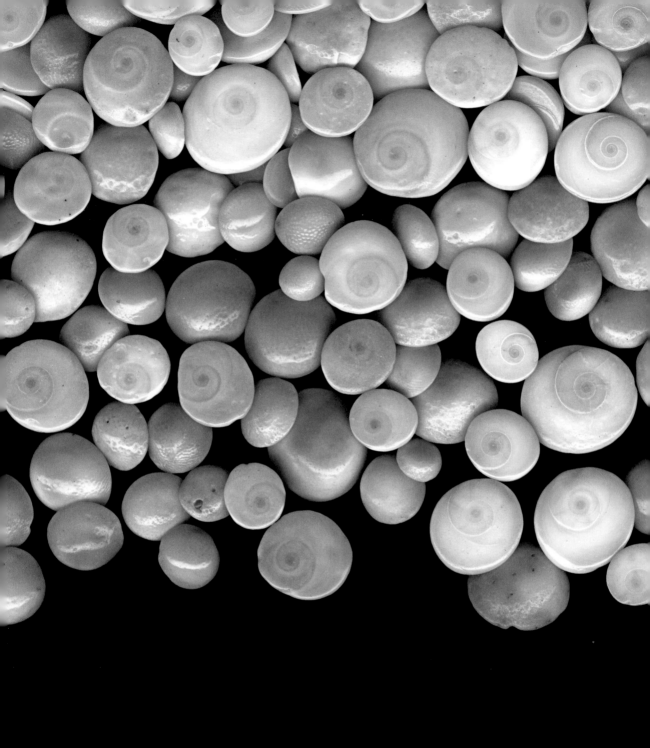

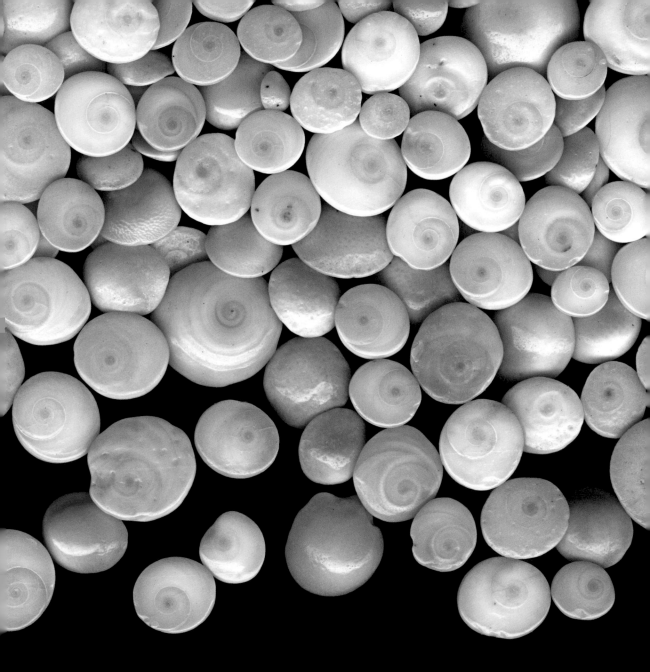

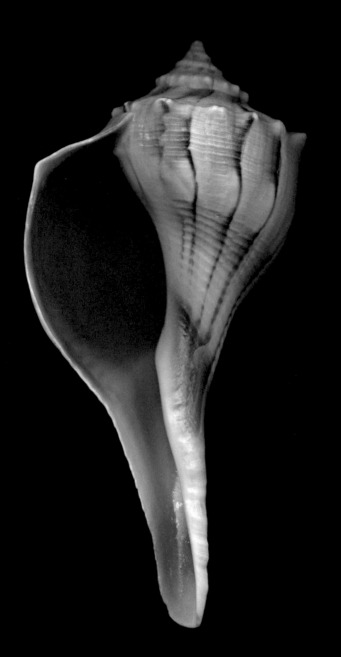

Lightning whelks. Florida and Georgia. As snail shells grow, they coil either to the right (dextrally) or to the left (sinistrally). Dextral or clockwise coiling, with the aperture on the right, is far more common in shells, just as right-handedness is more common in people. Sinistral coiling occurs in less than one percent of shells,

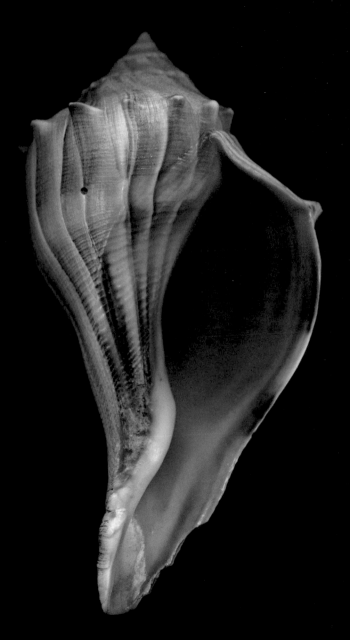

though one species of whelk called *sinistrum*, shown on the left, coils exclusively to the left. Crabs that attempt to prey on them have difficulty manipulating left-handed shells and often leave them be. Surprisingly, that advantage has not yet led to an increase in the frequency of sinistral coiling.

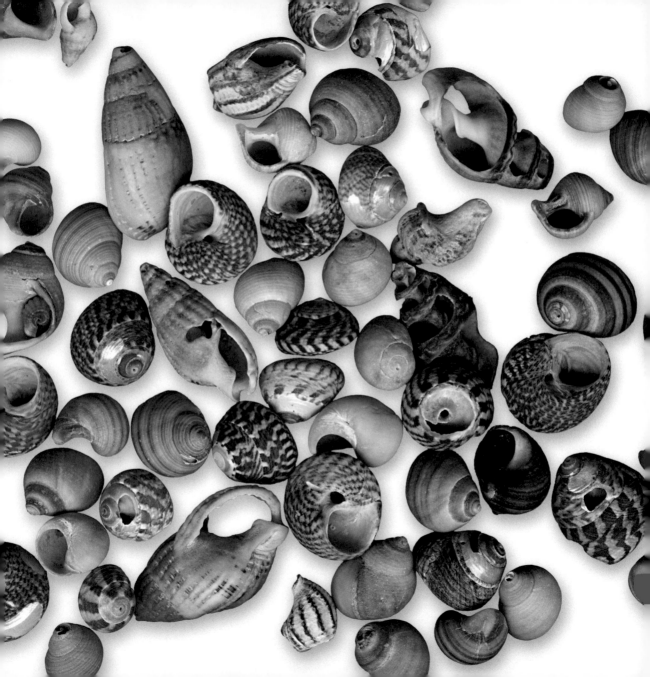

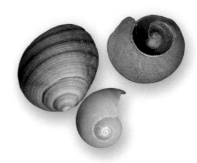

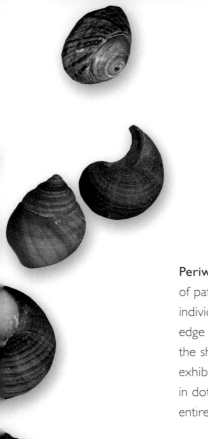

Periwinkles and other snails. France. Despite similarities of pattern and color within species, snail shells may be as individualized as fingerprints. The cells along the shell's growing edge generate pigments episodically, creating complex patterns as the shell enlarges. Some form spiral bands of color; other shells exhibit alternating bands of dark and light. Some are pigmented in dots and dashes, like Morse code, or distort unpredictably into entirely new patterns in midlife.

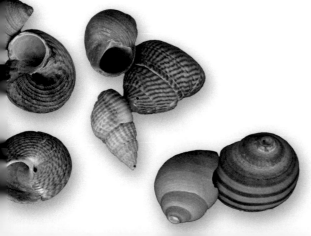

22

Trochid snail. Tasmania. Magenta spots pulse across this snail shell, decorating the surface but going no deeper. Pigments often are present only on the exterior and do not permeate the entire shell fabric.

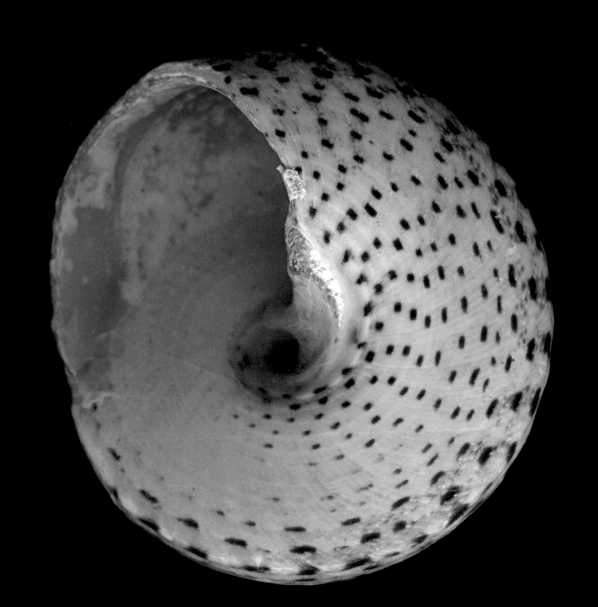

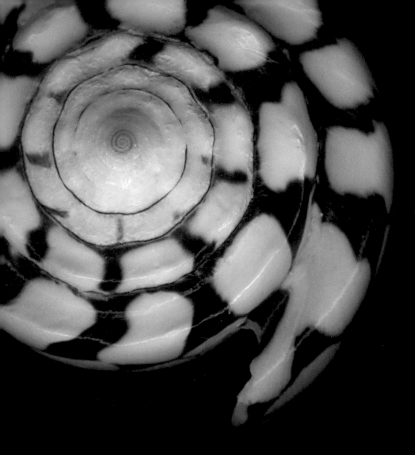

Marble cone snails. British Virgin Islands. The elegant marble cone snail has few rivals for lethal efficiency. A nocturnal hunter, it detects fish, snails, and other prey with its chemical sensors, then shoots a single, harpoonlike tooth into the unsuspecting victim's soft body, injecting a toxin that causes convulsions, paralysis, or both. A single cone snail's toxin is potent enough to kill any human unlucky enough to find himself within range of the harpoon.

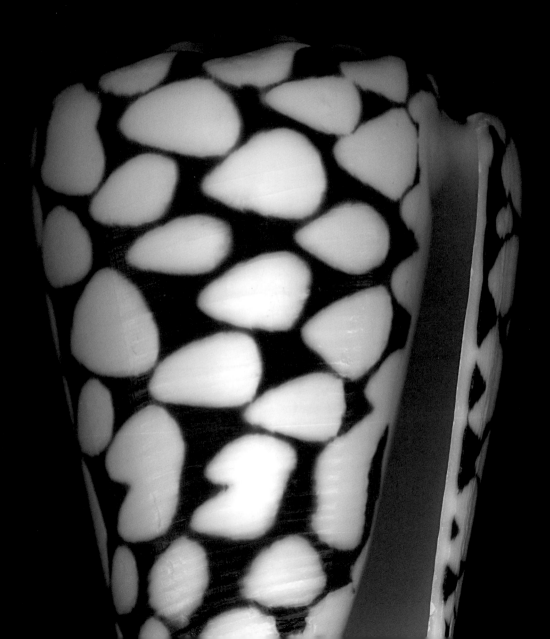

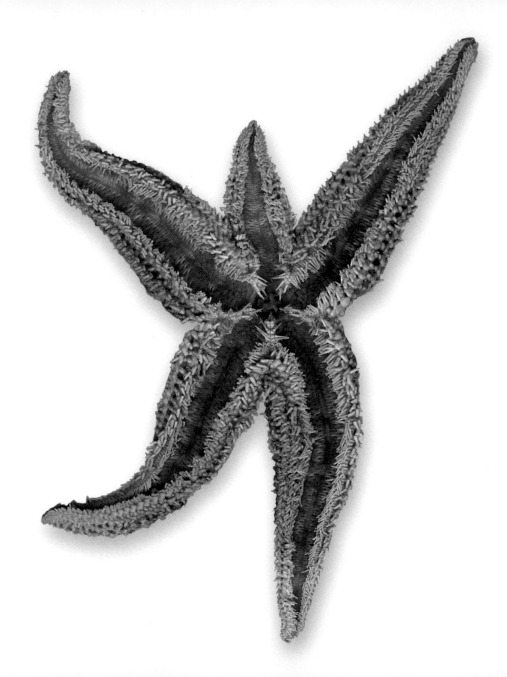

Opposite: **Sea star. Maine.** *Below:* **Sea biscuit. Bali.** Sea stars, sea biscuits, sand dollars, and sea urchins are echinoderms, not molluscs. All have a spiny skin—which is what "echinoderm" means in Greek. Sea stars may resemble Matisse's joyful dancers but are actually determined predators. With their hundreds of suckered tube feet attached to the two shells of their prey (mussels are a favorite), they pull and pull. They may keep pulling for days, until the mussel's muscles fatigue, allowing the valves to separate slightly, then inject it with digestive enzymes. They don't always emerge unscathed when attacked themselves, but sea stars can regenerate parts torn off by predators—the likely reason one arm here is smaller than the others.

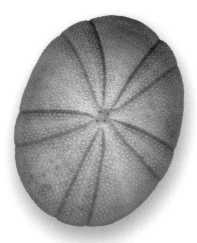

Arrowhead sand dollar. Baja California. The fivefold symmetry characteristic of echinoderms is evident in this splendid sand dollar, whose five leaflike petaloids radiate from a central star-shaped plate on its back. This plate sieves seawater entering the water vascular system, unique to echinoderms and used for locomotion and feeding. The four distinct holes at the tips of the star are conduits for the release of eggs or sperm.

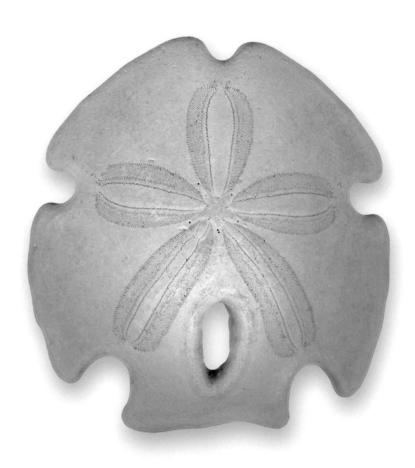

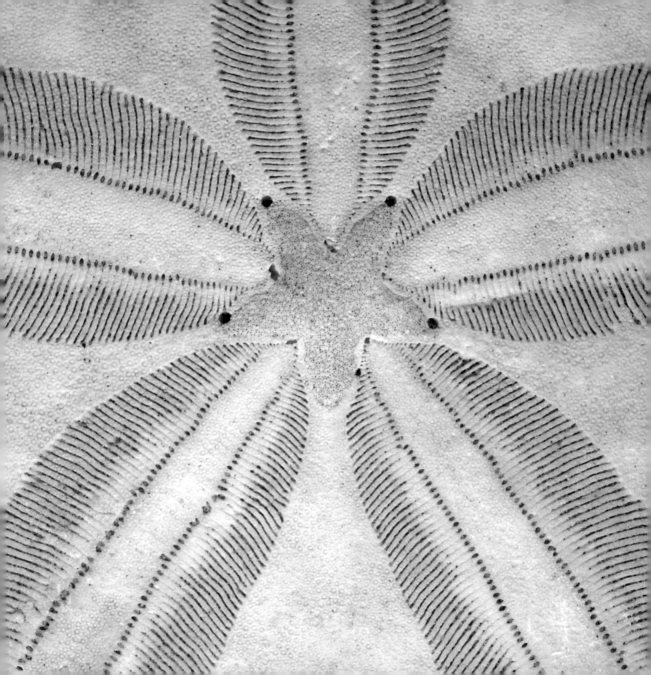

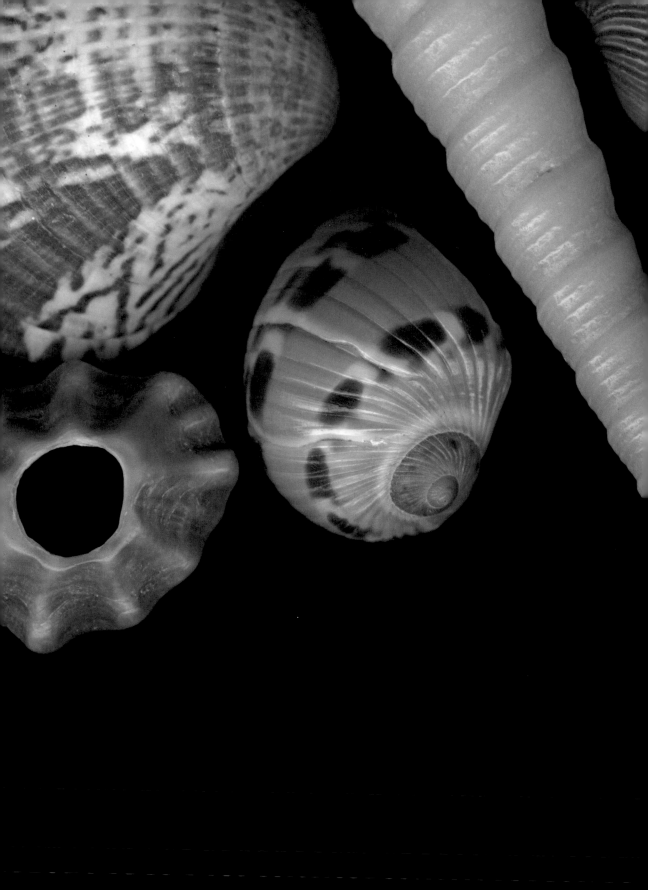

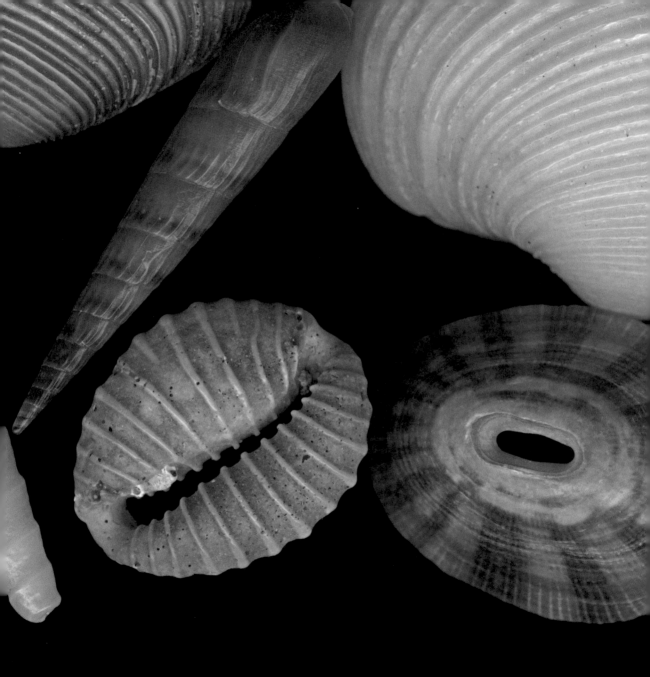

Coralline red algae. Northern California. Similar in appearance to a skeletal hand, these are the remains of a type of algae that deposits a calcium carbonate mineral in its cell walls. The calcified segments are connected by flexible joints, allowing coralline algae to bend with the tidal flow, like tree branches swaying in the breeze.

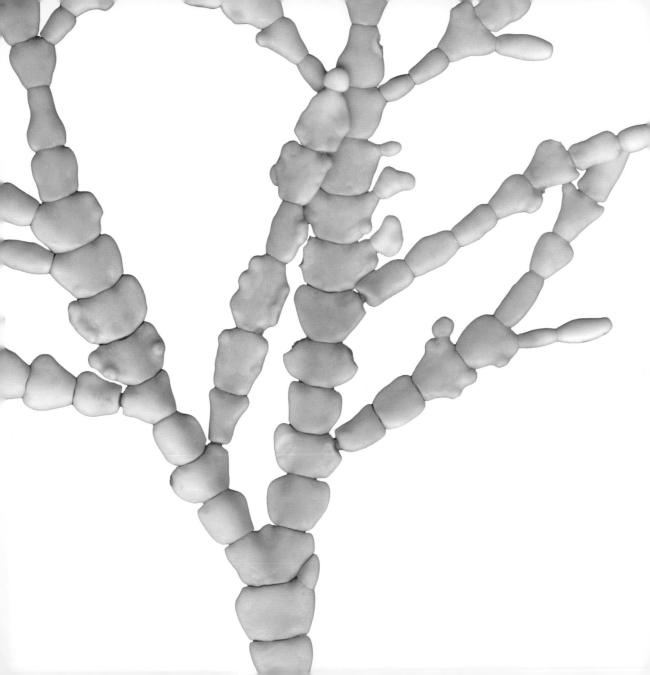

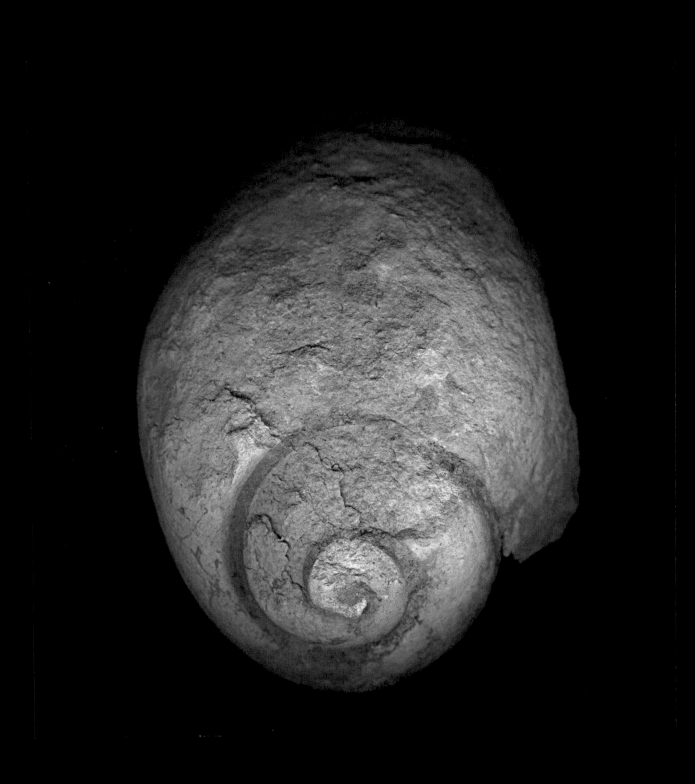

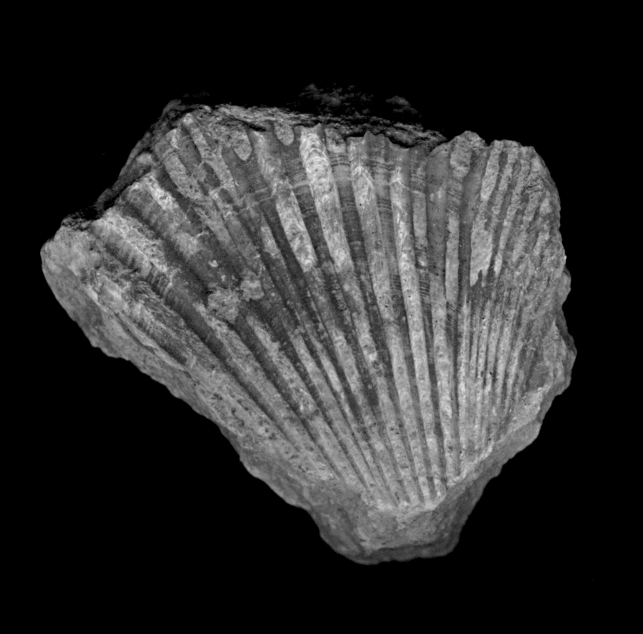

Preceding pages: **Snail and scallop fossils (Cretaceous). Tunisia**. After death, organisms are exposed to a wide range of chemical, physical, and biological processes that transform them from biological to geological equilibrium. The snail shell that preceded this fossil is now largely gone; it was composed of aragonite, a mineral that easily dissolves over time. What is left is an internal cast formed by sediment that filled the shell shortly after the snail's soft tissues decayed. By contrast, the scallop's shell was largely calcite, which is more resistant to dissolution than aragonite, and some of the original shell remains.

Opposite: **Fossil shell hash (Pliocene). Northern California.** These seashells, fragmented and jumbled with sediment by waves and currents in life, were later cemented together by chemical processes involving ocean and groundwater (and possibly bacteria) and preserved as fossils in this weathered rock.

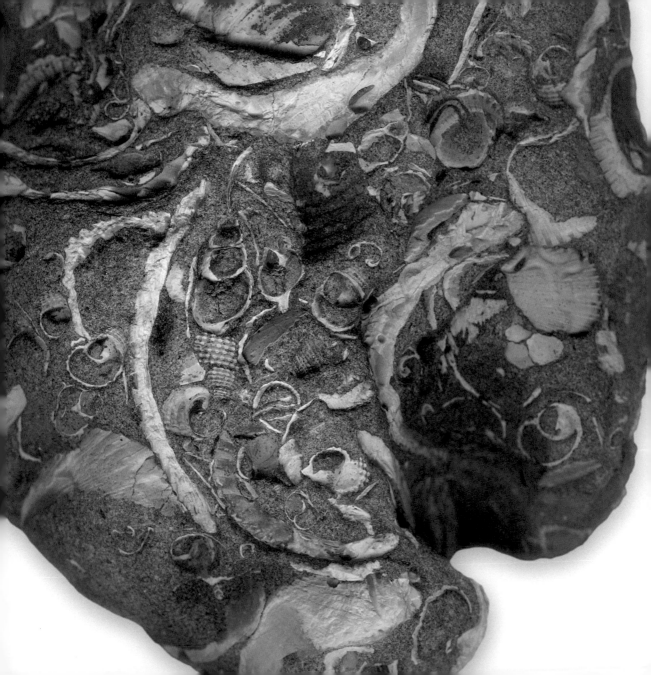

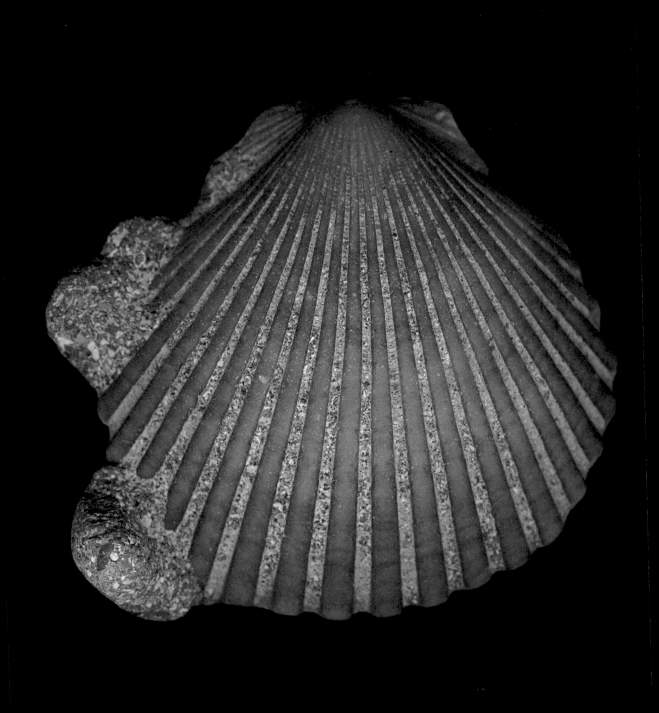

Opposite: **Scallop fossil (Tertiary). South Carolina.** The iconic scallop remains strong and graceful in fossilized steel gray. It is now devoid of other color because pigments have been chemically leached out of the shell. Sediment neatly fills the grooves between the rounded ribs, and attached lumps of sandstone remind us that this once living organism is now a component of the geological record. It is still dignified in its beauty, even millions of years after death.

Following pages: **Beaded cowries. Hawaii.** The wonderfully bumpy shells of these cowries are hidden in life by large flaps of fleshy mantle tissue. Some cowries have differently colored and patterned mantles and can transform their appearance by drawing them within the slitlike shell aperture—quick-change artistry that can confuse predators.

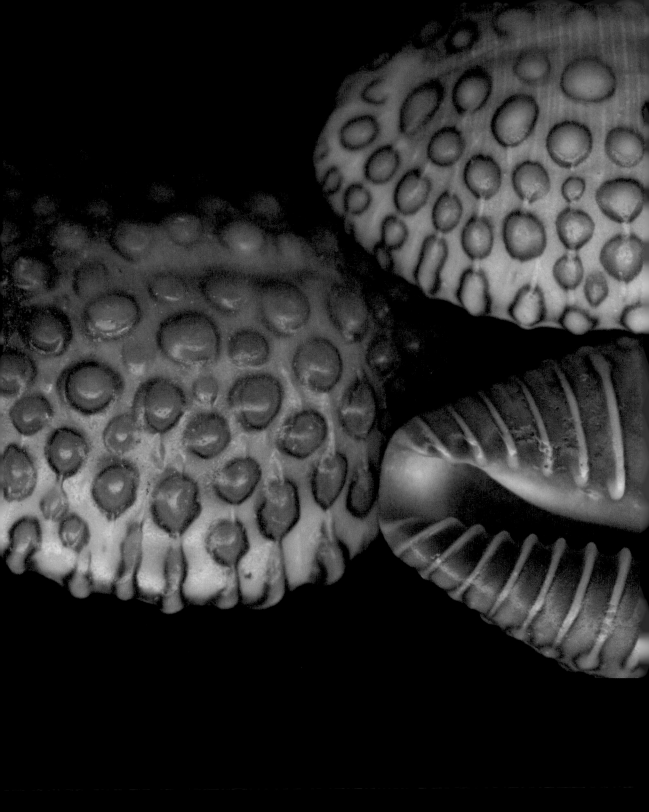

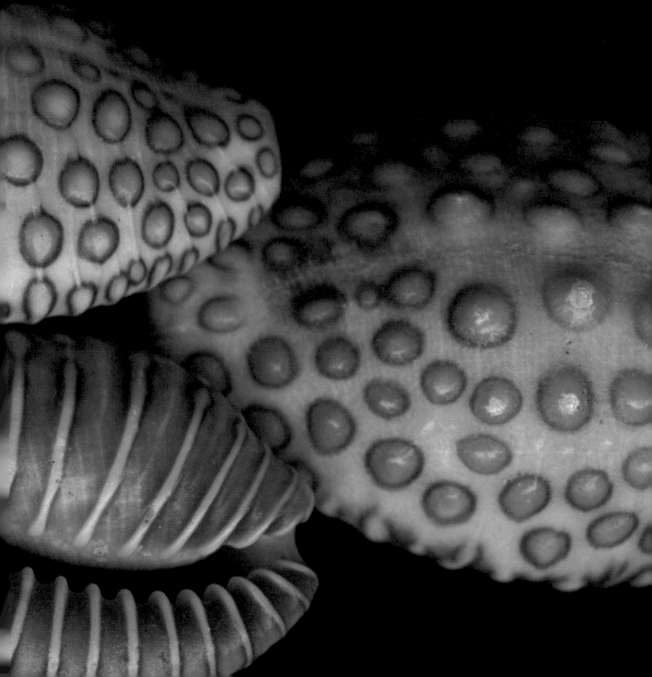

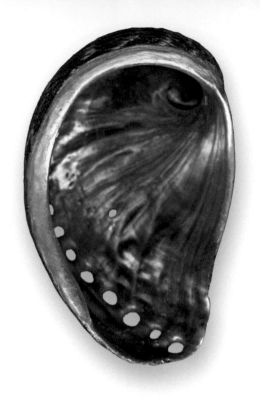

Abalone. Northern California. The abalone's shimmering inner layer of mother-of-pearl, also called nacre, is formed from small, thin, overlapping plates of calcium carbonate secreted by the abalone. The sequinlike nacreous plates reflect light at varied angles, producing the lustrous, ever-changing colors of mother-of-pearl. Bona fide pearls are made when abalone, pearl oysters, and other bivalves coat irritating particles, such as sand grains, with many, many layers of nacreous plates.

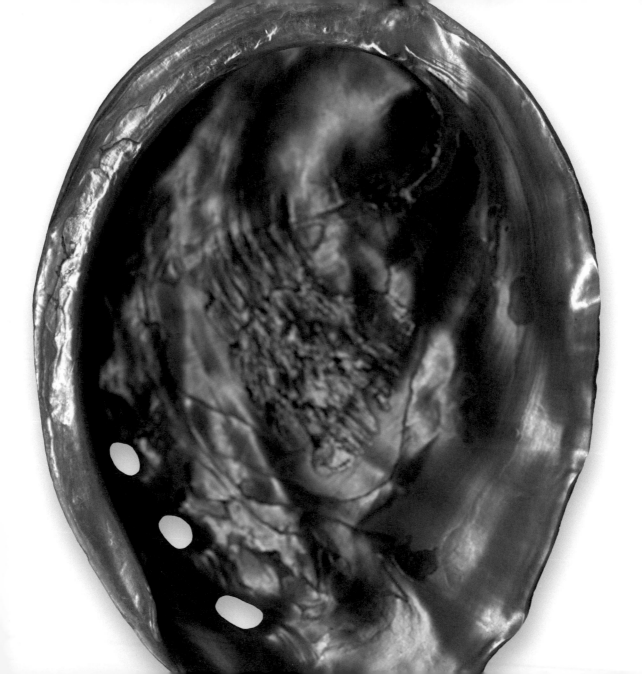

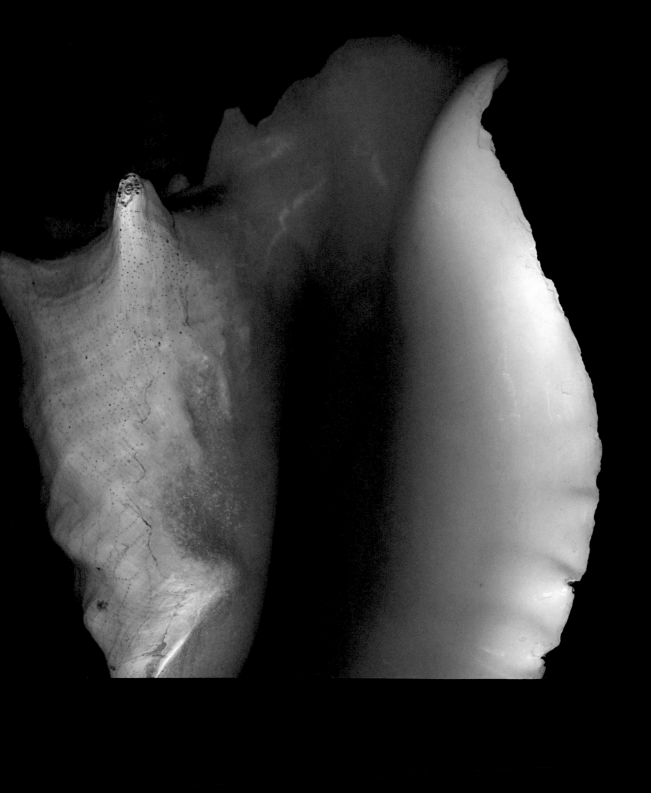

Queen conch. Belize. Most snails move by crawling slowly, at a snail's pace, on their muscular foot, carrying their shell with them. The inhabitant of this large queen conch shell, which weighs in at more than four pounds, would have moved slowly even for a snail. Limited mobility can make predation difficult; understandably, queen conchs are vegetarians. They tend to live in warm, shallow waters with abundant algae, which can't escape being eaten.

45

Weathered pieces of clam shells. Massachusetts. Shells were among the earliest forms of currency, with cowries used as money in China as long ago as 1200 BCE. They lend themselves well to the job: Durable and easy to carry, shells are plentiful near the coasts but increasingly rare and valuable inland. Native North Americans traded wampum—smoothly worn pieces of shell and shell beads—for goods. "Shelling out money" originally meant just that, and "clams" came to be a synonym for "dollars."

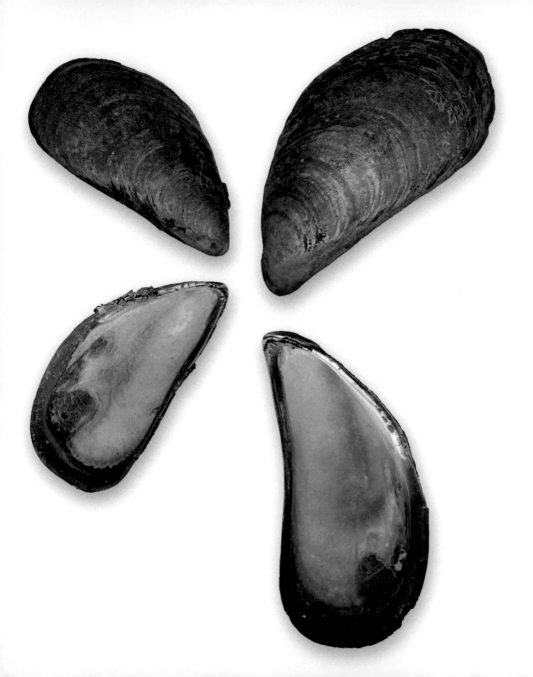

Preceding pages: **Mussels and chthamaloid barnacle. Northern California.**
Opposite: **Acorn barnacles. Maine.** Barnacles are crustaceans, more closely
related to lobsters and shrimp than to clams. They attach to surfaces submerged
at high tide, such as ship bottoms, pier pilings, rocks, and mussels. Some grow
and reproduce rapidly, quickly conquering all available space, as they have on this
rock, now a barnacle-encrusted heart. In contrast, the chthamaloid barnacle, seen
on the mussel on the previous page, grows quite slowly and remains tiny into
adulthood. When barnacles are exposed at low tide, their beaklike inner plates
close up to keep their bodies moist inside. At high tide they open, allowing their
feathery legs to extend to rhythmically comb the water for food.

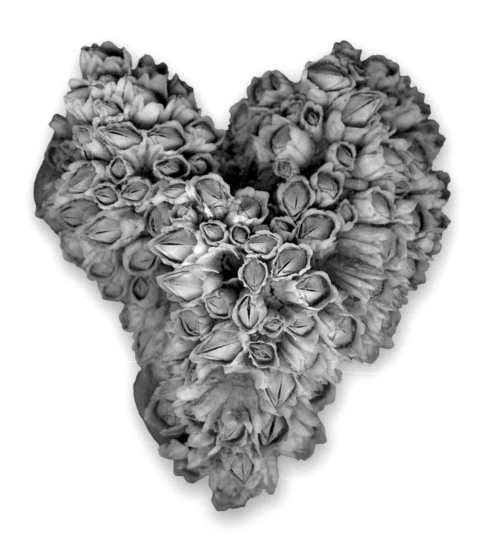

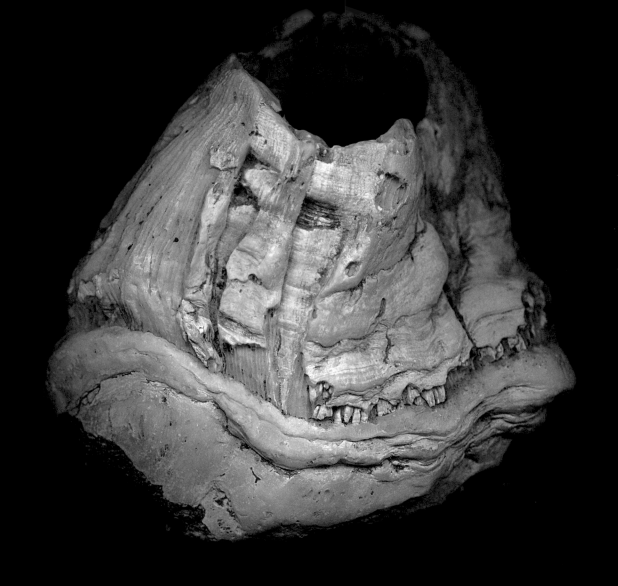

Acorn barnacle. Northern California. Acorn barnacles build massive, cone-shaped fortresses of calcium carbonate plates, which become larger and thicker with age. Like all other crustaceans, barnacles molt or periodically shed the exoskeleton covering their bodies, but their mineralized outer fortress keeps them safe from predators. After death, the beaklike inner plates detach and wash away, while the outer plates, fused together and cemented in place, remain behind, like a silent, dormant volcano.

53

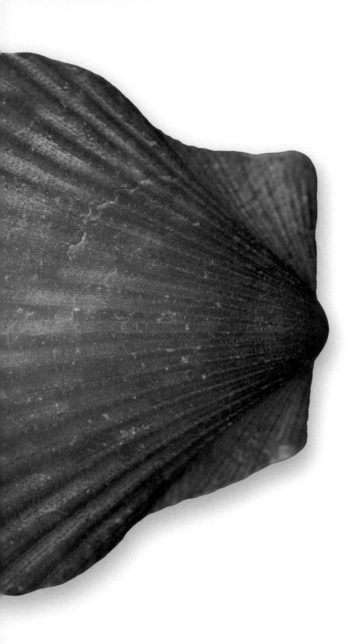

Atlantic bay scallop. South Carolina. Most bivalves burrow or anchor themselves in soft sediment or spend their lives attached to a rock or other hard surface; scallops are among the few that can swim. They contract and relax their single large adductor muscle—the part humans and other predators dine upon—to clap

their two valves open and shut, moving via an awkward sort of jet propulsion. Some species can swim more than thirty feet in a single burst. Asymmetry in the "ears" along the hinge can cause scallops to swim in a wobbly zigzag; it may not be graceful but often allows them to scoot away before becoming someone's lunch.

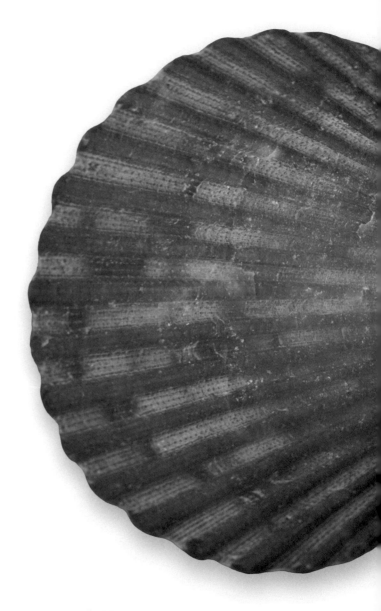

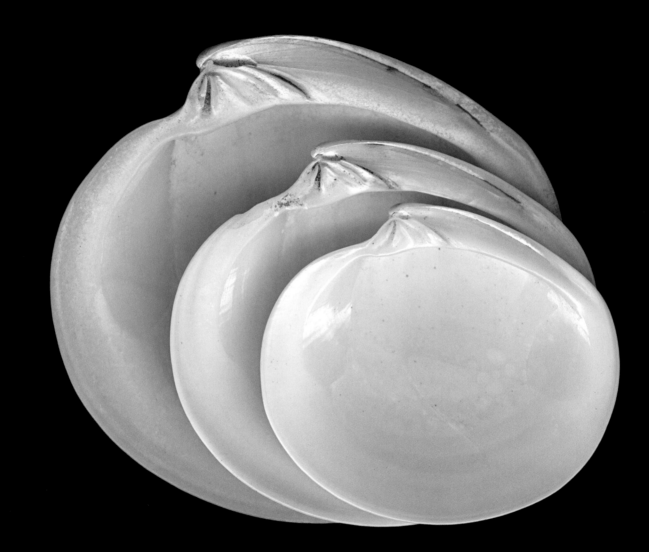

Venerid clams. Georgia. The sea offers up an endless variety of elaborately shelled creatures—intricately chambered, steeped in color, awhirl with pattern, and intriguingly textured with frills and spines. But there is much to be said for the simple beauty of a pure white clam, smooth, shiny, and cleanly sculptural.

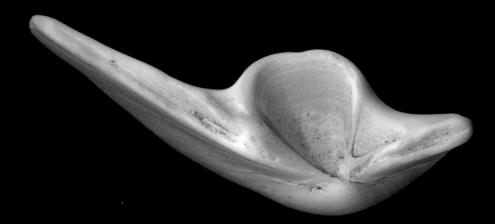

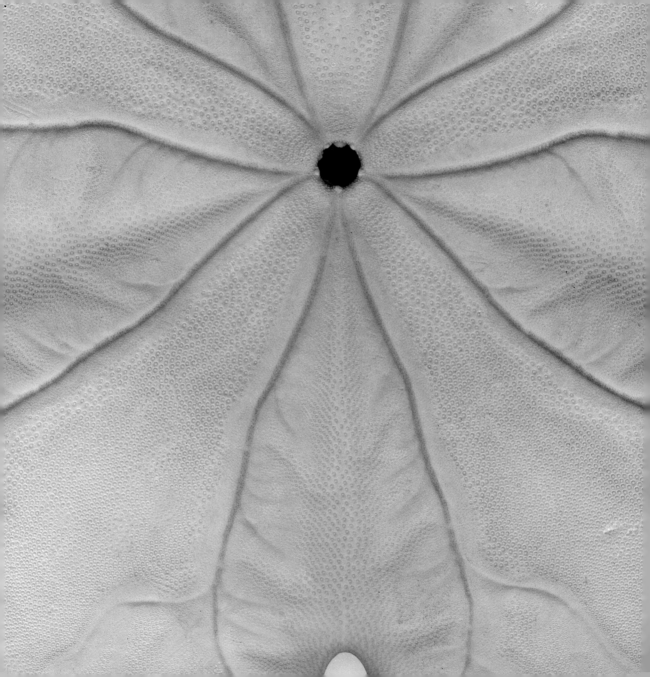

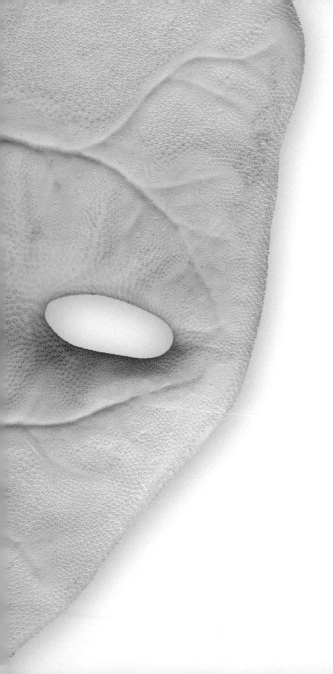

Sand dollar. South Carolina. In life, the smooth white sand dollars that wash up on the beach are covered by a dense stubble of short, brown spines and are as dark and fuzzy as flattened kiwi fruits. The thousands of subtle bumps on the skeletal surface mark where the spines attached. Rotating spines and agile tube feet enable sand dollars to move on and through sandy sediments. Then, perched on edge like large coins stuck in the sand, sand dollars gather food, with five pairs of gently meandering grooves guiding particles toward the mouth in the center. Lunules—elongate openings that let water flow through—help keep the animals upright in a strong current.

61

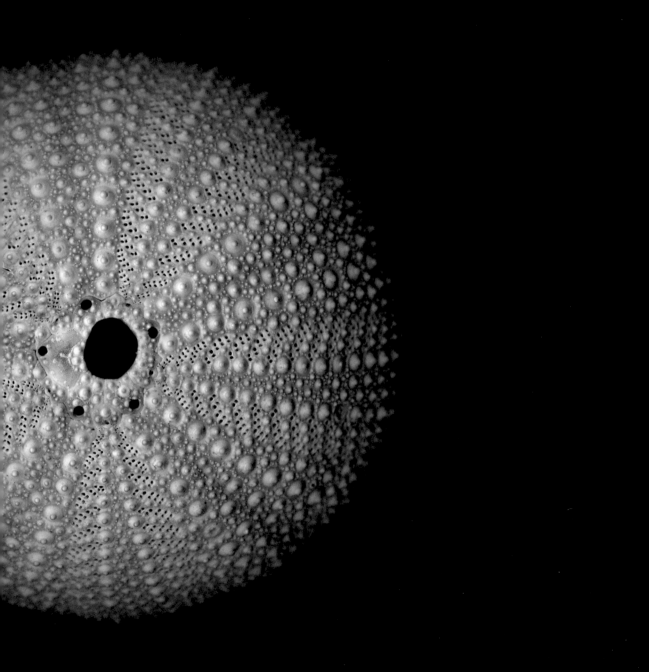

Sea urchin. Maine. Like animated pin cushions, sea urchins move across the sea floor waving their tube feet and spines as they feed on algae. The neat rows of bumps mark the ball-and-socket joints where the spines attached. Ten strips of small paired holes between the rows of bumps show where tube feet once extended. The ethereal green is characteristic of some species; others may be purple, pink, or red.

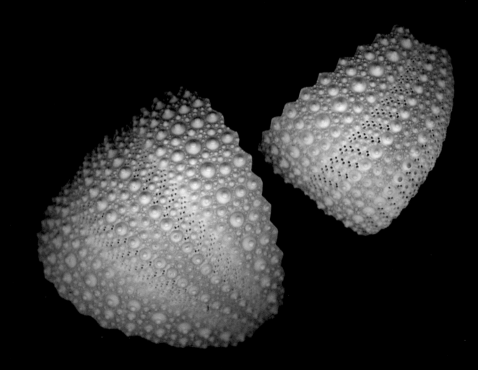

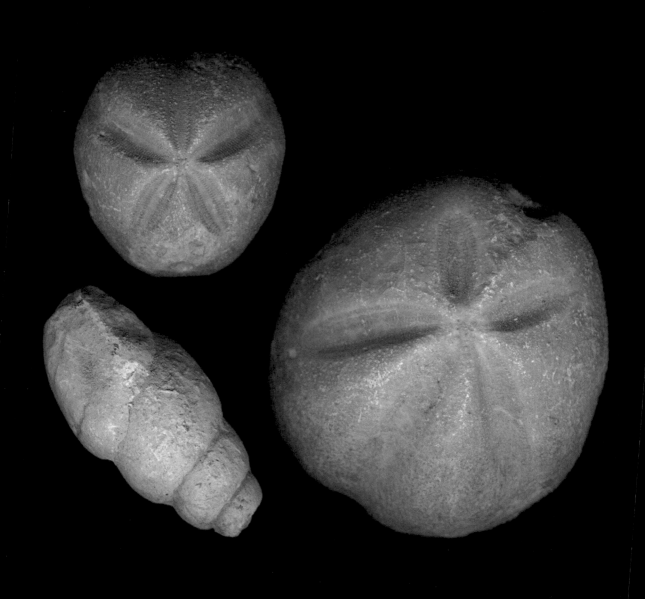

Sea urchin and snail shell fossils (Cretaceous). Tunisia. While dinosaurs were grazing and hunting on land, these organisms were quietly making a smaller-scale living offshore. Despite their antiquity, they look remarkably like their present-day descendants. At any time following death, one or more of the many processes of fossilization could have destroyed the shells, preventing their discovery millions of years later. Fossilized shells are exceedingly rare compared to the number of shelled organisms that once lived.

Sand dollar fossils (Pliocene) and fragments. Northern California. A single beach outing can reap sand dollars that are two months old and two million years old. The white shell fragments here are the skeletons of recently deceased sand dollars; the one to the lower right reveals a hint of the intricate internal architecture as well as the round mouth. The smooth, cracked surfaces of the four fossil sand dollars resemble ancient mosaics missing a few tiles here and there. Entombed in layers of gray sandstone, the fossils were ripped up in pieces of rock and tossed upon the beach by winter storms.

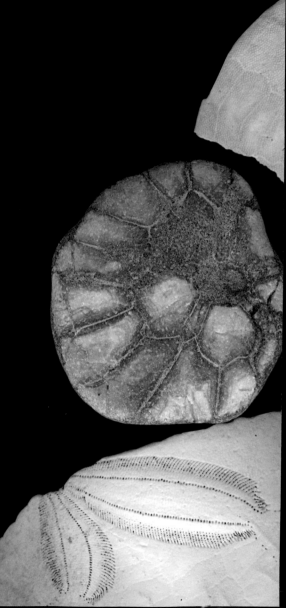

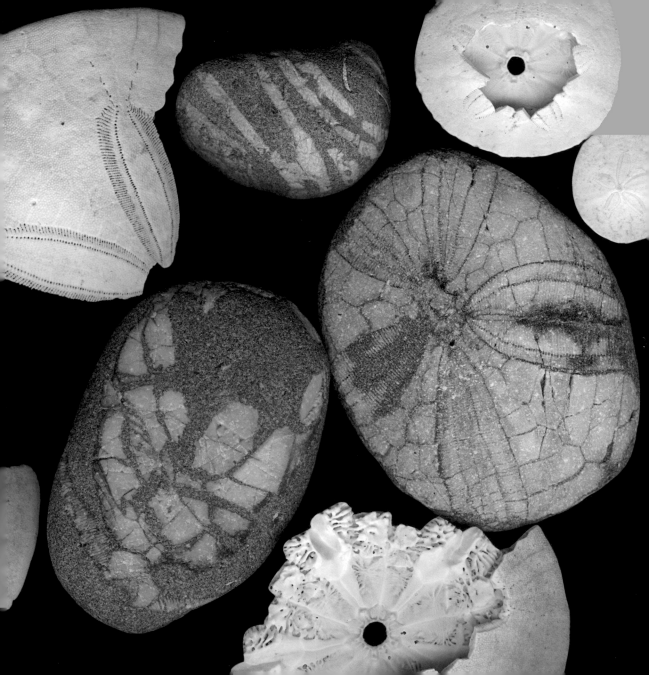

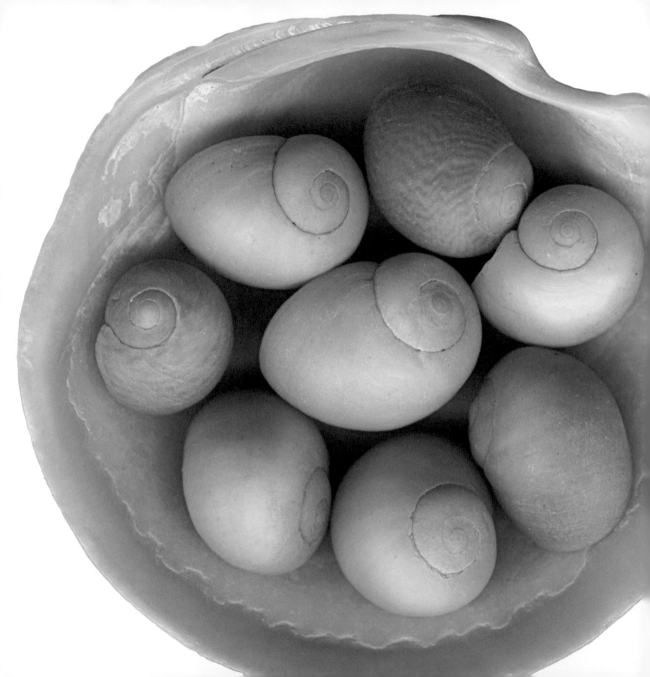

Naticid snails. Maine and France. Lucinid clam. France. A clutch of yolk yellow snails nestles in a golden clam shell. The pigment responsible for their vivid hue is a carotenoid, from the same group of compounds that imbues carrots with their bright orange color.

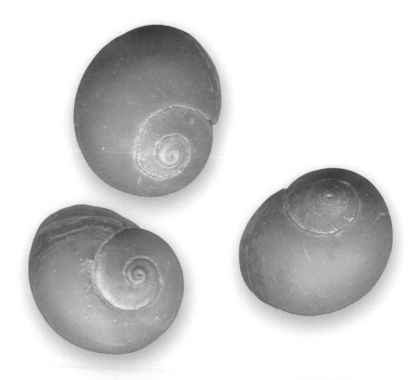

70

Opposite: **Fossil brachiopod (Cretaceous). Northern California.** This fossil's shape and ornament superficially resemble those of the scallop, but this shell belongs to a group of bivalved organisms with entirely different ancestry. Brachiopods are among the most common marine fossils because their calcite shells resist dissolution and because they were abundant and enjoyed high species diversity for hundreds of millions of years.

Following pages: **Brachiopods. Southern California.** Brachiopods attach permanently to a hard substrate with a stalklike pedicle that emerges from a small round hole at one end of the larger valve. Most are extinct, but some, like these terebratulides, have survived in deep or cold water where predation is less intense. Their translucent, blush pink shells expose the branching canals that held eggs or sperm and look eerily like veins visible through skin.

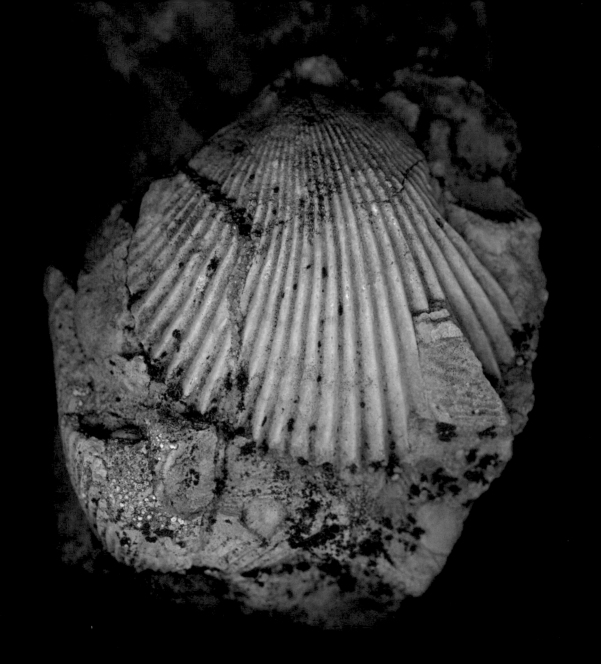

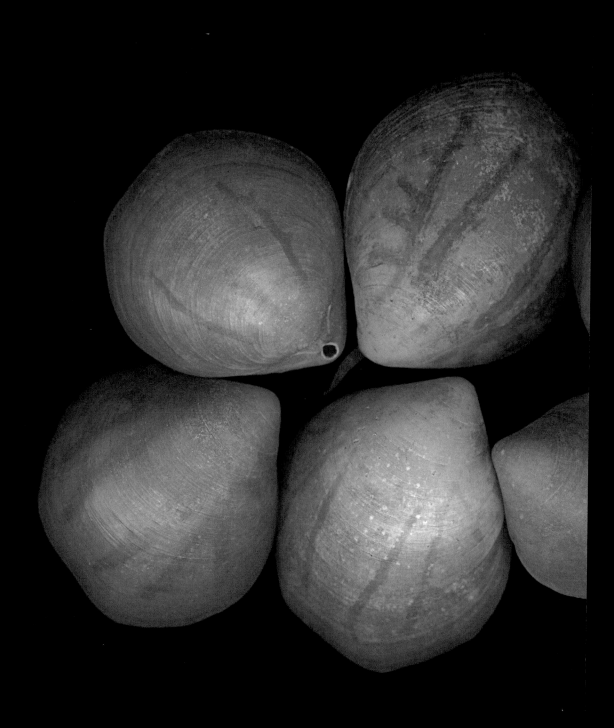

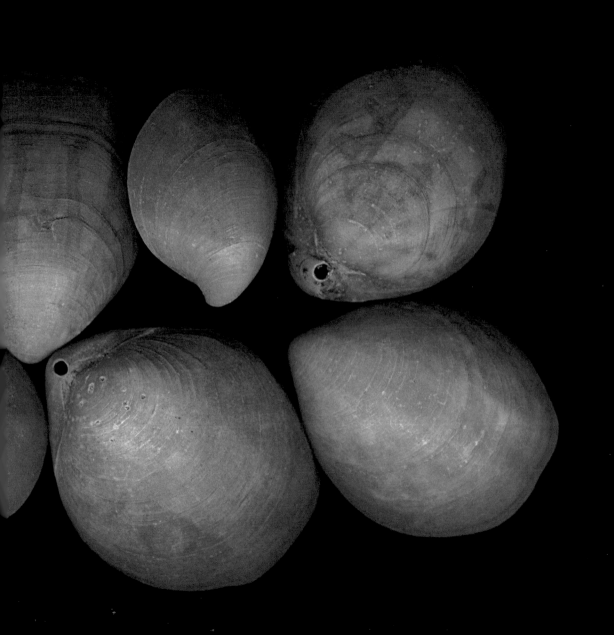

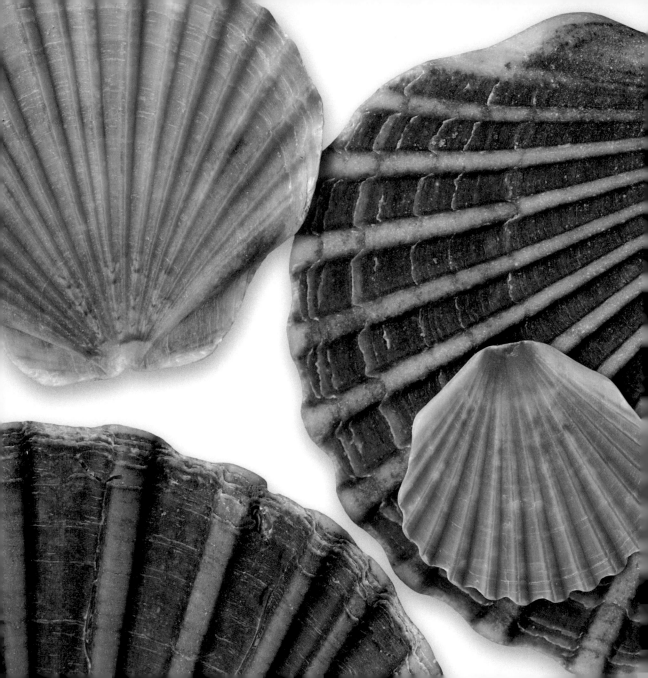

Scallops. Guam. The fanlike ribs that radiate over many bivalves' shells can help stabilize them on shifting sands, increasing surface area and friction, like a washboard. And, as corrugation does for cardboard, ribbing can strengthen a shell, making it harder for predators to chip off, drill through, or break. For swimmers like these scallops, ribs enhance seawater's lift or reduce its drag.

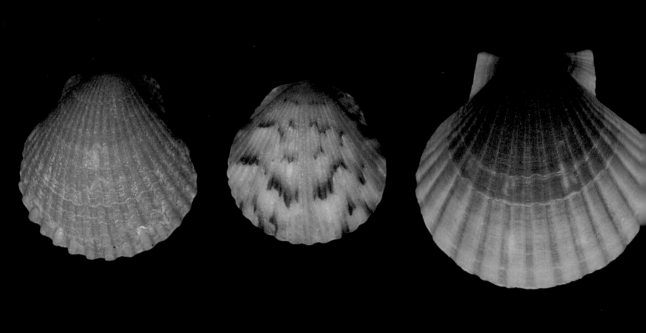

and somewhat mysterious. A single pigment might be responsible
for different colors in individuals of the same species, but two
different pigments can produce the same color in separate species.

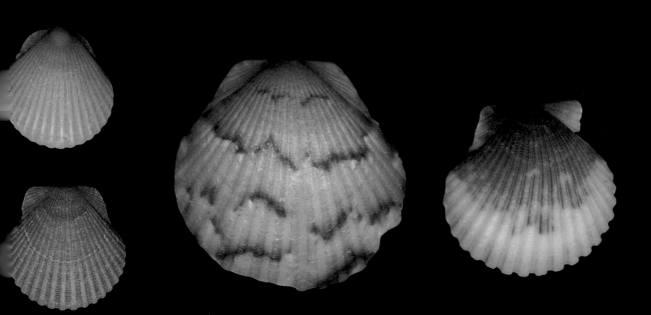

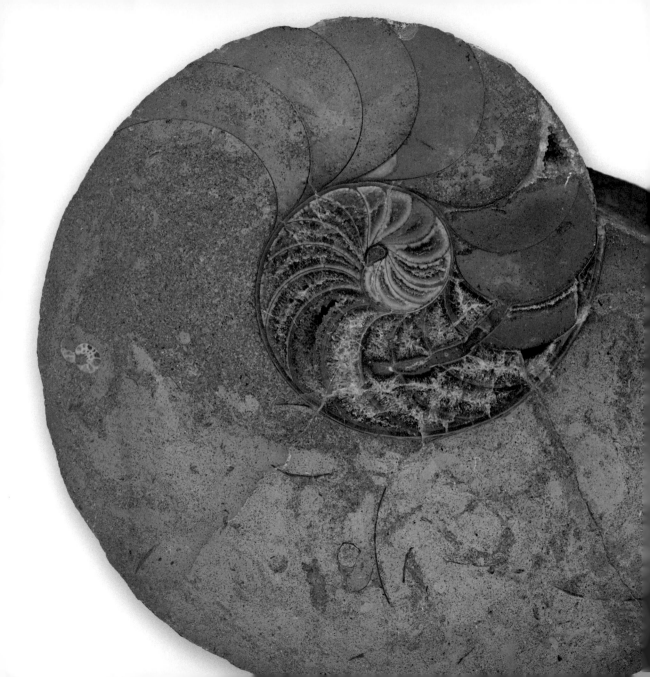

Nautiloid fossil (Cretaceous). South Dakota. Long extinct, this nautiloid mollusc had a chambered internal structure (exposed in this sectioned view) similar to that of its present-day relative, the *Nautilus*. Its body moved forward as it mineralized ever-larger additions to its spiraling shell. The advancing body periodically secreted a gently concave septum behind it, sealing off rear portions of the living chamber. Gases and fluids in the inner chambers were regulated via a tube called a siphuncle (visible near the middle of this fossil), which controlled buoyancy.

Lucinid and tellinid clams. Venezuela.
Genetically uniform color, such as the pink
and yellow of these delicate clams, can be a
disadvantage to molluscs whose predators have
color vision. But shell color sometimes serves to
ward off predators by warning them of toxins
that lurk inside. Color can also be camouflage,
making the shell blend in with the substrate.

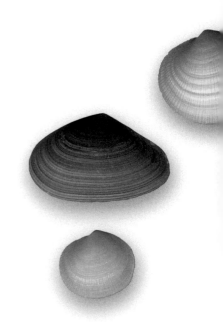

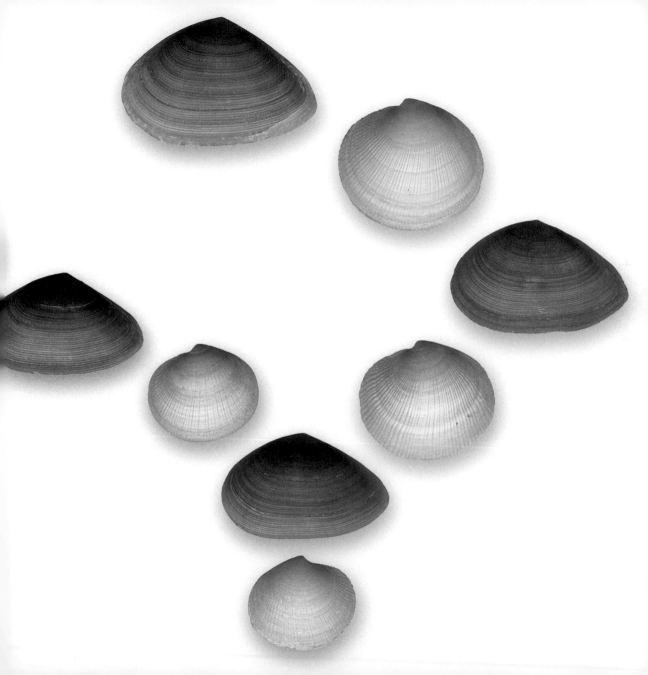

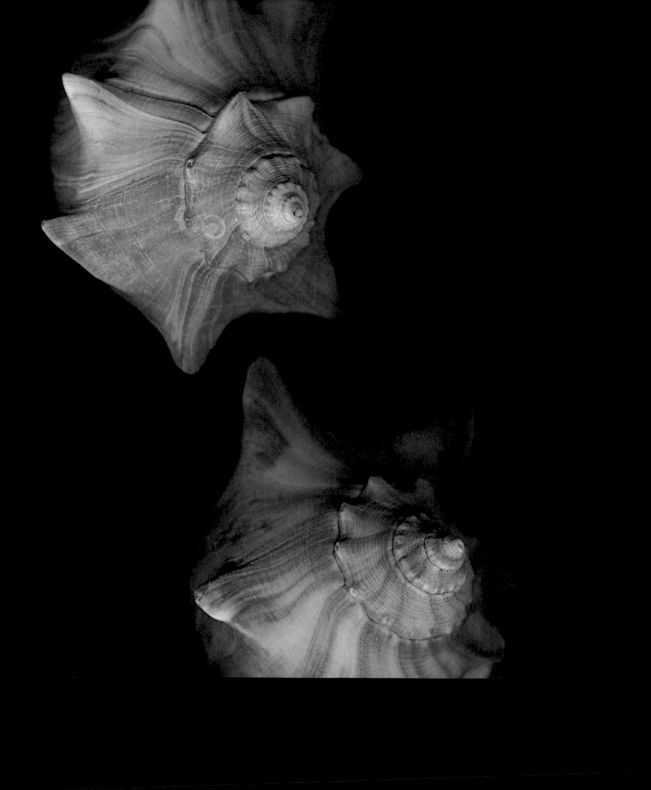

Lightning whelks. Georgia. Nature's rough handling has beautifully exposed one whelk's slender, ballerinalike columella, the central column or axis around which the shell spirals. The snail's columellar muscle whorls around it, fastening the body to the shell at only one point, the apex. As the muscle contracts and relaxes, it slides up, down, and around the columella, polishing it to a high sheen. The many tiny holes are caused by boring sponges, which penetrate and inhabit the center of the shell fabric, thus gaining a protective covering without having to create one themselves.

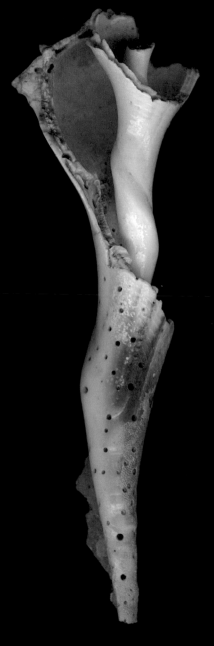

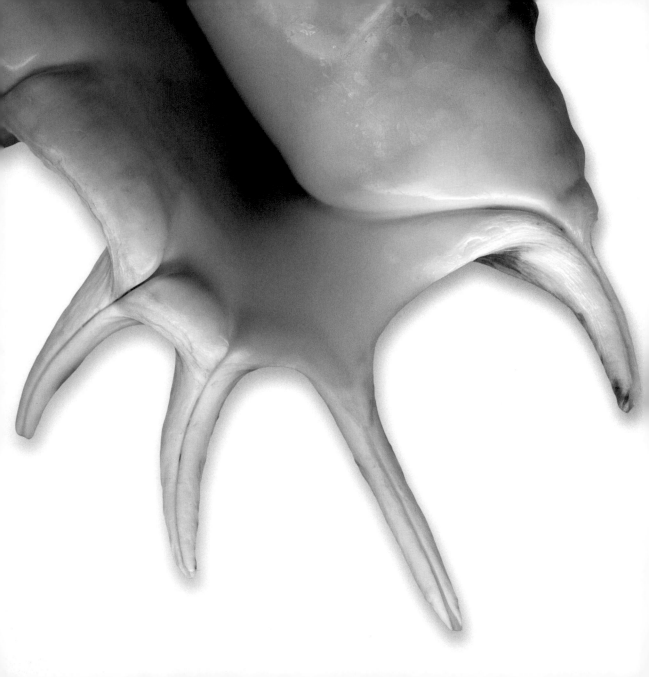

Spider conch. Australia. A flared lip and long hollow spines signify the spider conch's sexual maturity, when this snail invests more resources into reproduction than growth. Snail shells are mineralized from mantle tissue, a kind of mollusc "skin," which advances evenly during rapid, normal growth. At sexual maturity, growth of the spider conch's mantle tissue slows or stops, and it develops evenly spaced, elongated, and enrolled projections (like curled tongues sticking out), which mineralize the spines as they retreat. The retreat of the mantle projections is visible along the seams running down each spine.

85

Muricid snail. Hawaii. The vertical rows of sharp, prickly spines on this lovely yet well-defended *Murex* are called varices; they grow episodically over the course of the snail's life. In ancient times, people extracted from this and several other species of marine snails a colorless glandular secretion that, when exposed to sun, produced Tyrian purple dye. Tens of thousands of snails were needed to make a single pound of the precious, deeply hued dye. Used to color the robes of Roman senators, Tyrian purple was known as the "emblem of imperial authority."

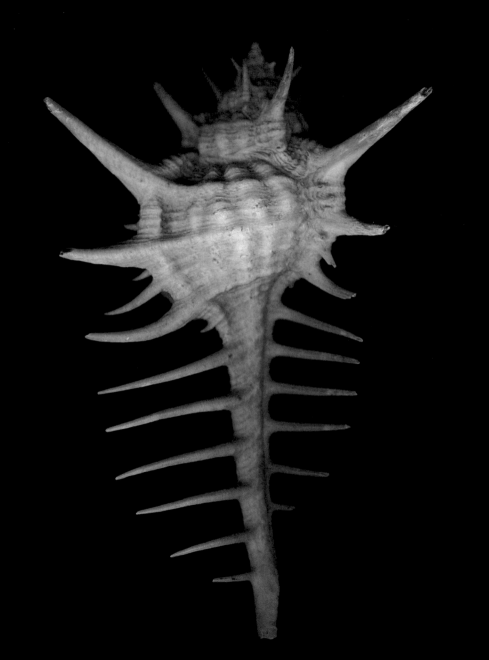

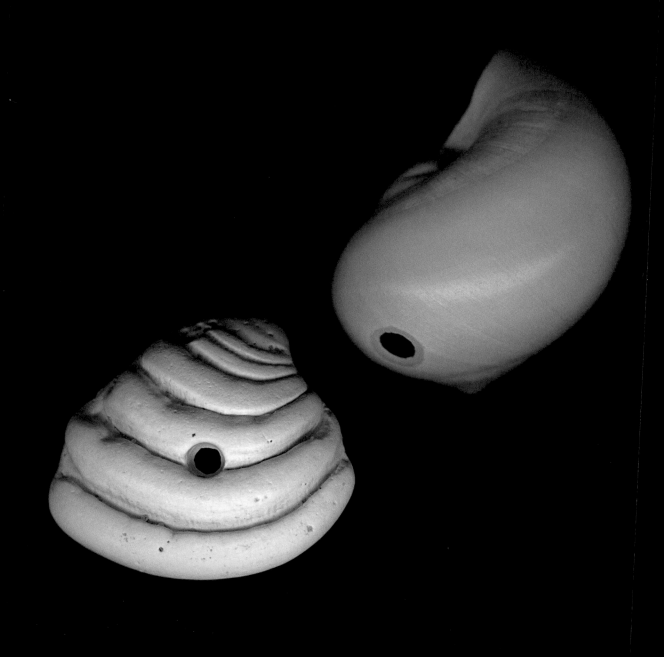

Opposite: **Venerid clam and naticid snail. Georgia.** The round holes in these shells testify to their occupants' cause of death, by cannibalistic naticids, or moon snails. The snail manipulates prey with its large, muscular foot, positioning the thinnest part of its victim's shell beneath its mouth. Holding the prey firmly in place with its foot, it begins slowly boring a circular beveled hole, a naticid signature. It continuously scrapes and rasps its radula, a kind of tooth-covered tongue, over the vulnerable spot, weakening it further with shell-dissolving secretions, until it gains access to its hard-earned meal.

Following pages: **Vermetid snails. Panama.** These convoluted tubes are worm snail shells, looking like an ancient, undecipherable hieroglyph. They first grow like typical snails but then cement themselves to a hard substrate and begin twisting and meandering unpredictably.

89

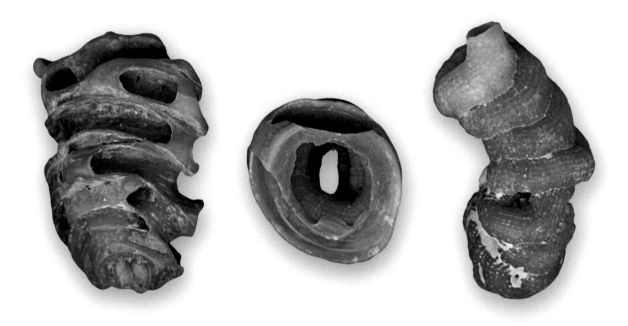

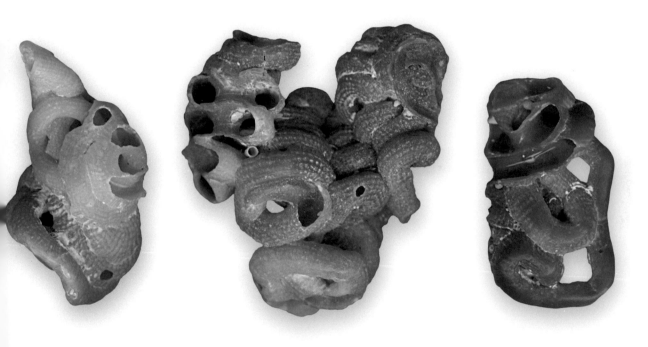

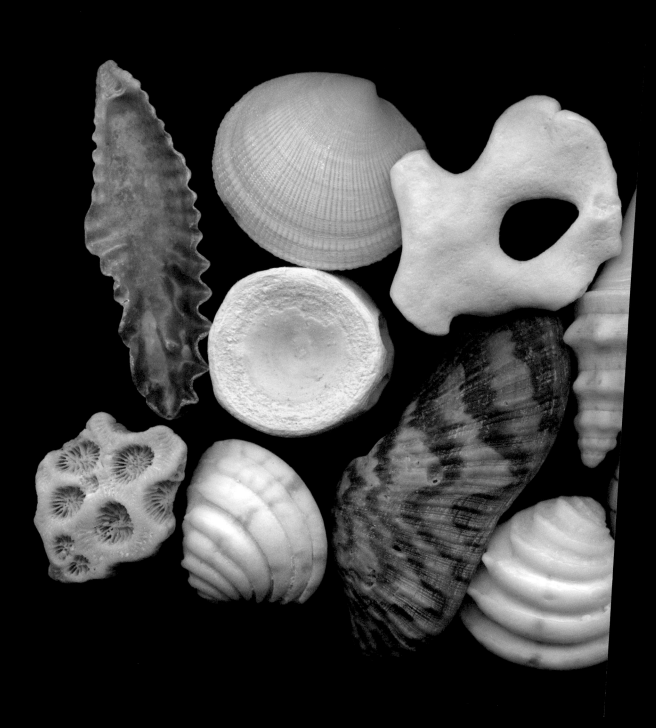

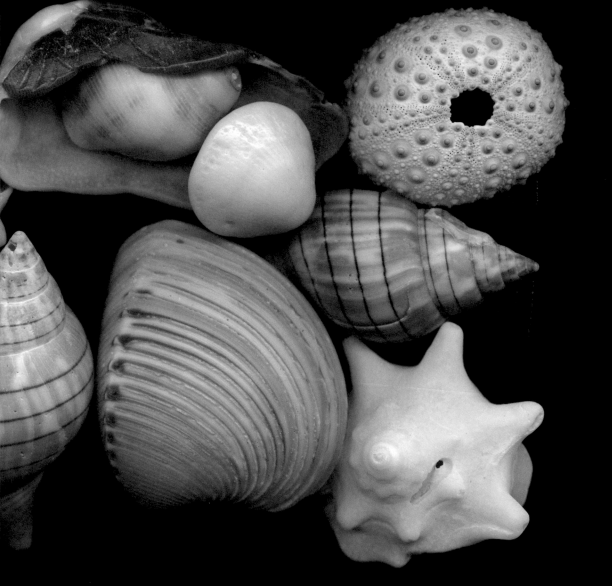

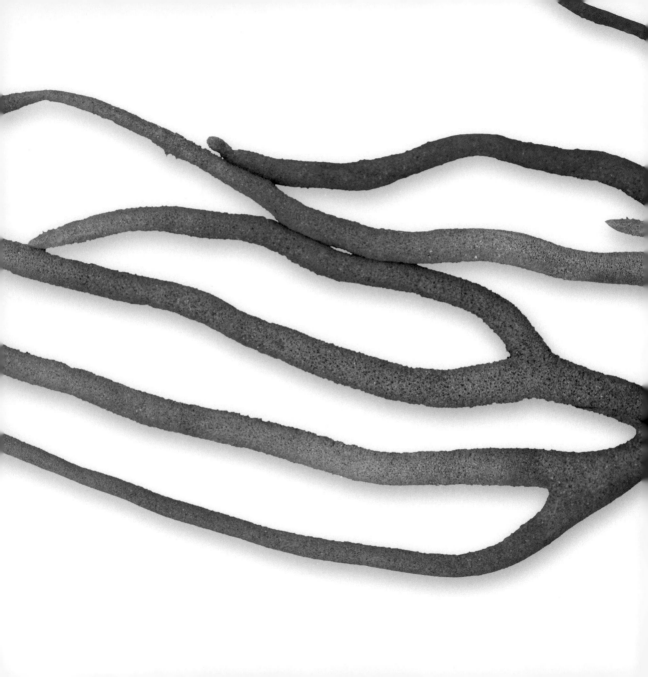

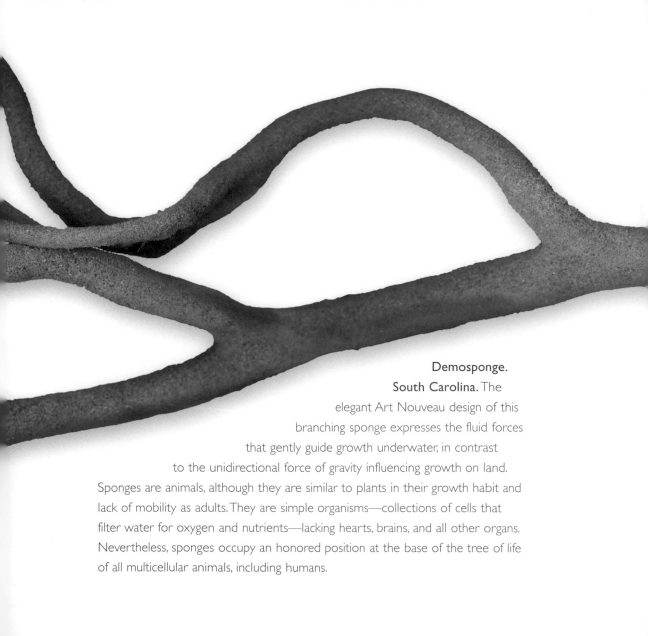

Demosponge.
South Carolina. The
elegant Art Nouveau design of this
branching sponge expresses the fluid forces
that gently guide growth underwater, in contrast
to the unidirectional force of gravity influencing growth on land.
Sponges are animals, although they are similar to plants in their growth habit and
lack of mobility as adults. They are simple organisms—collections of cells that
filter water for oxygen and nutrients—lacking hearts, brains, and all other organs.
Nevertheless, sponges occupy an honored position at the base of the tree of life
of all multicellular animals, including humans.

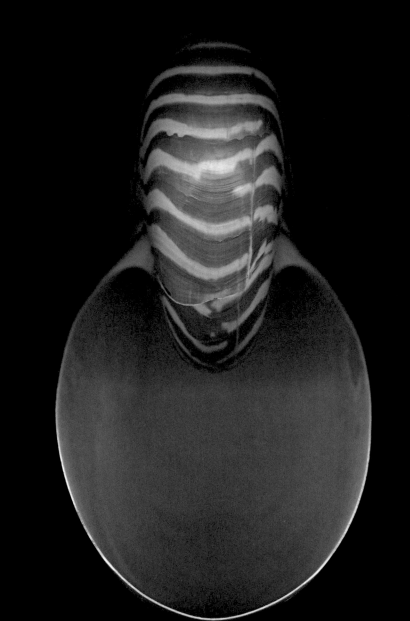

Nautilus. **Indonesia.** Like Captain Nemo's submarine of the same name, the chambered *Nautilus* migrates vast distances up and down the water column daily. It dwells deep along the steep slopes of Pacific Ocean coral reefs—as far down as fifteen hundred feet—to avoid predators active above during the day. But at night it slowly rises, adjusting gas pressure in its chambers for buoyancy. Once it reaches its preferred hunting depth, it pursues crustaceans and other prey using rapid jet propulsion, swimming as its powerful muscles expel water previously taken in.

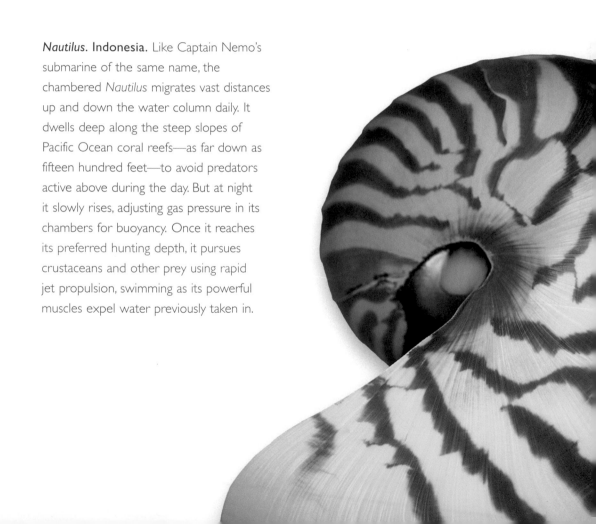

Ammonite fossils (Cretaceous). South Dakota. These deeply ridged pinwheels were members of a once abundant, diverse, and geographically widespread group of cephalopod molluscs that became extinct along with terrestrial dinosaurs sixty-five million years ago. Like the pits on a golf ball, ridges on shelled cephalopods may have decreased drag as the animals jet propelled themselves through the ocean in search of prey. During medieval times ammonites were thought to be coiled, petrified snakes, and a fossilized ammonite may have been the original discus used in the ancient Greek Olympics.

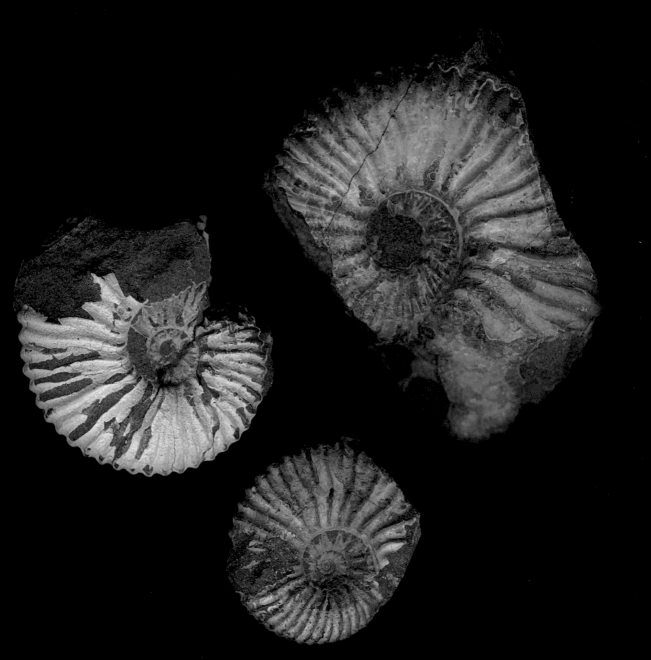

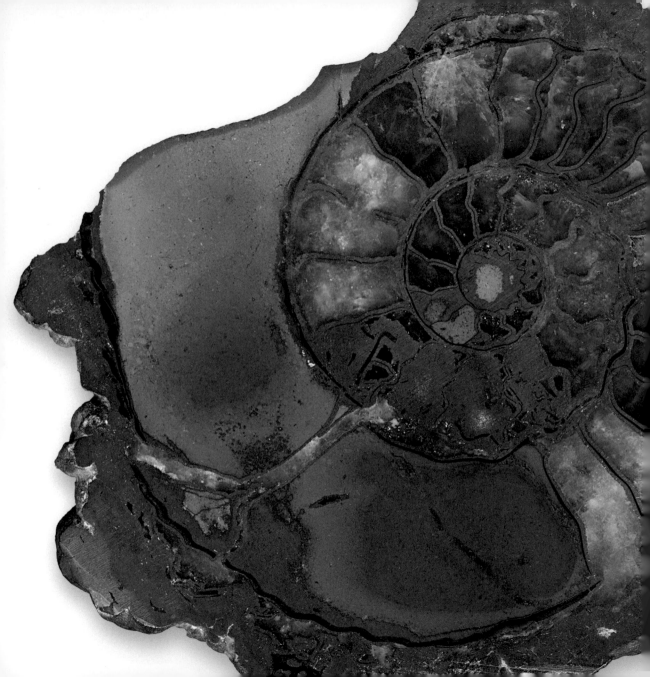

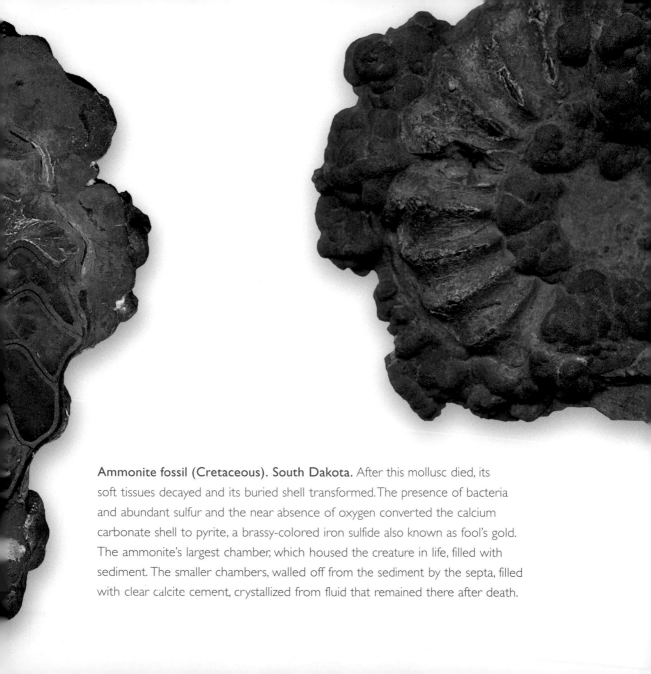

Ammonite fossil (Cretaceous). South Dakota. After this mollusc died, its soft tissues decayed and its buried shell transformed. The presence of bacteria and abundant sulfur and the near absence of oxygen converted the calcium carbonate shell to pyrite, a brassy-colored iron sulfide also known as fool's gold. The ammonite's largest chamber, which housed the creature in life, filled with sediment. The smaller chambers, walled off from the sediment by the septa, filled with clear calcite cement, crystallized from fluid that remained there after death.

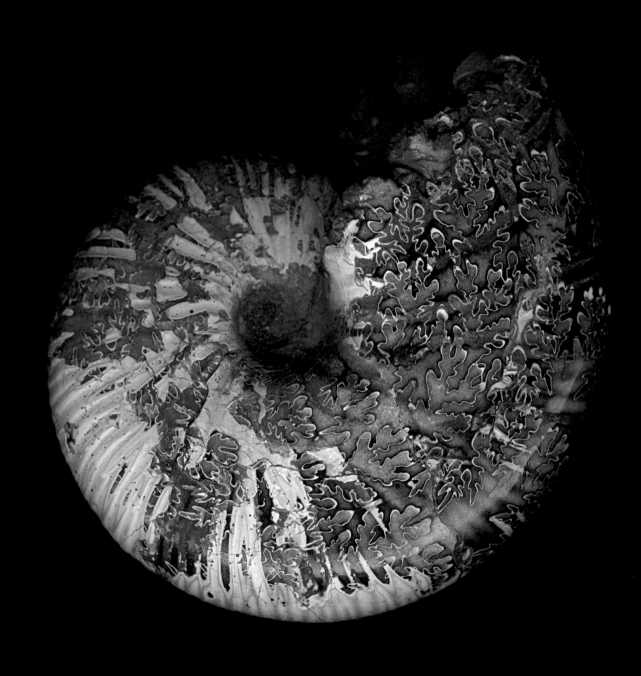

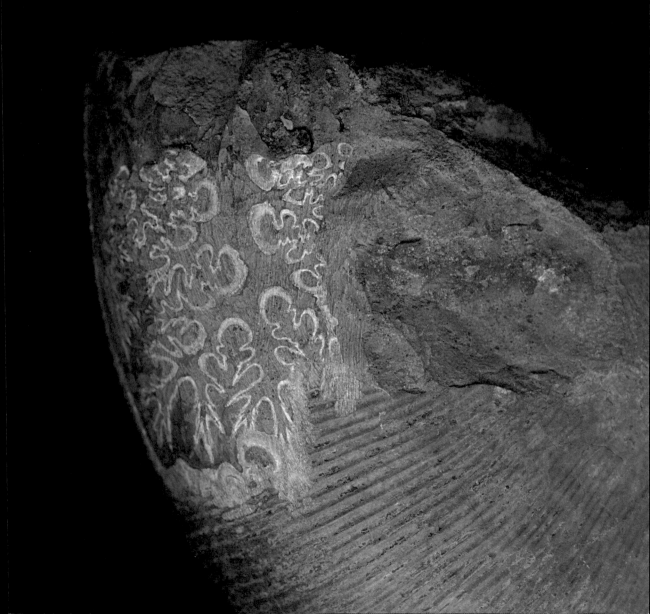

Preceding pages and opposite: **Scaphitid ammonite fossils (Cretaceous). South Dakota.** The convoluted lobed patterns on these ammonites are called sutures. Revealed by the erosion of the shell's external layer, they appear where the septal walls dividing the shell chambers intersect with the outer shell. Unlike their cousins the nautiloids, which have simple, concave septa, ammonites have septa with complex edges, traced by flamboyant suture patterns. Elaborate septal edges may have strengthened the shell by increasing the septal surface area in contact with it, reducing the likelihood of shell implosion as the ammonite descended to greater pressure at depth.

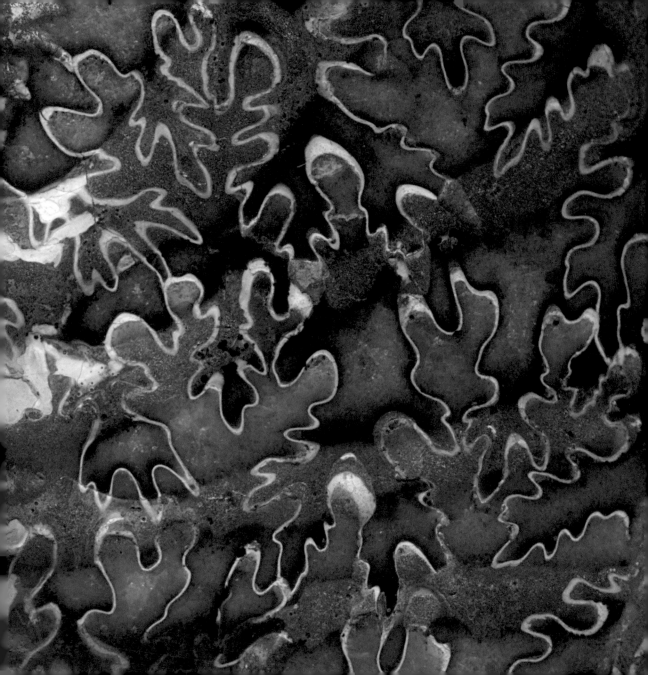

Spirula. **Spain, Kenya, and Australia.** Translucent, milky white, and as small as fingernails, these are the internal calcareous shells of *Spirula*, cephalopods related to cuttlefish and squid. (They are shown here about four times lifesize.) Like nautiloids and ammonites, their many-chambered shells coil in a flat spiral. Delicate-looking but hardy, *Spirula* are found as deep as three thousand feet in oceans around the world. Living *Spirula* are bioluminescent; they are visible as tiny dots of light in the sea, which may be one reason they form a major part of the diet of certain seabirds.

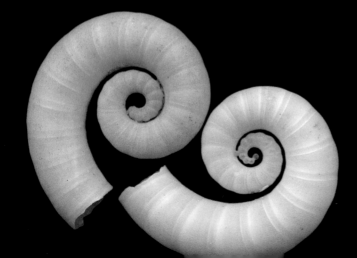

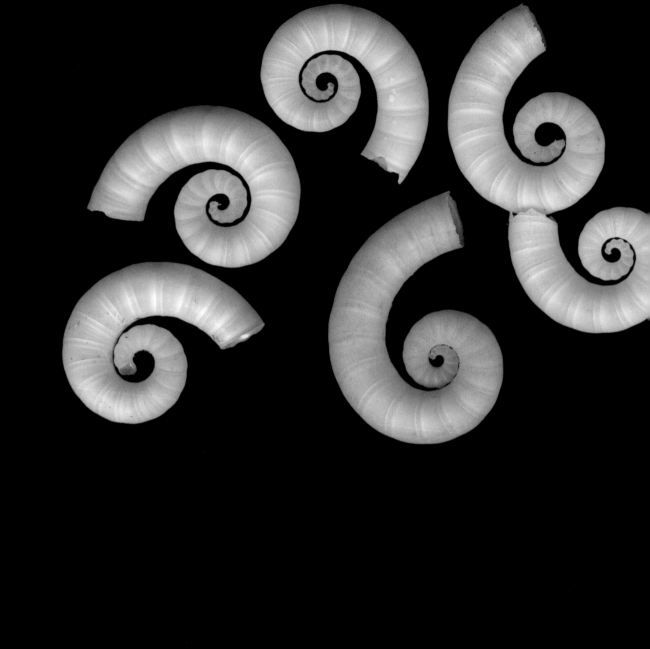

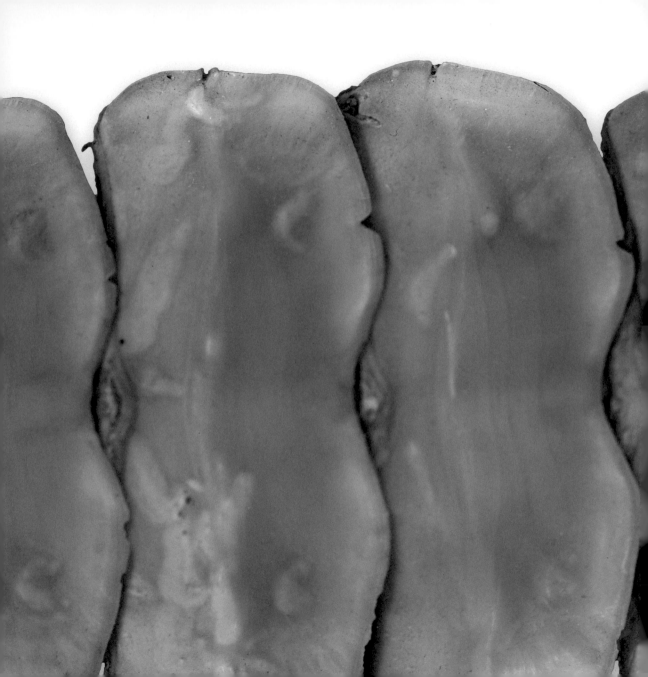

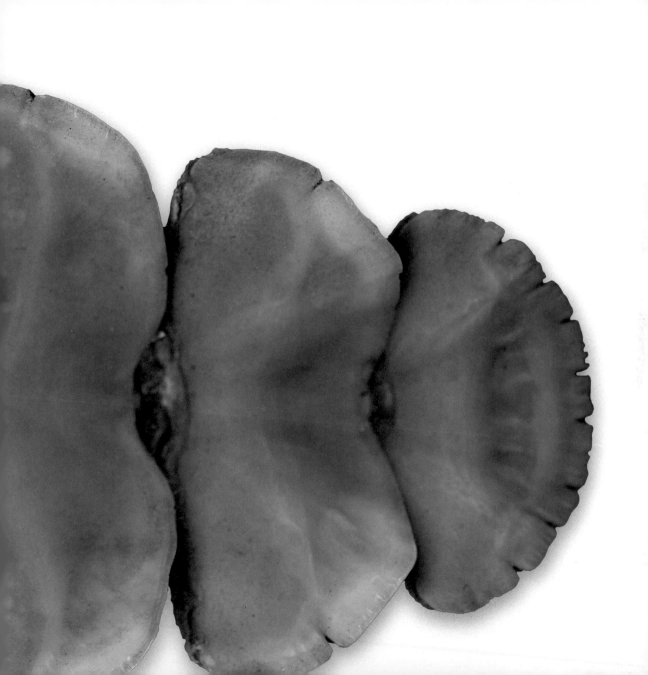

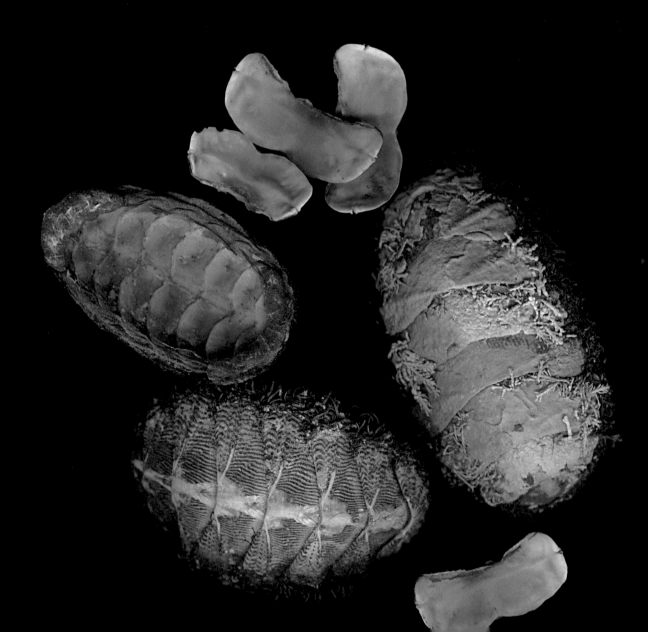

Preceding pages and opposite: **Chitons. Northern California.** Chitons are a curious group of molluscs with eight overlapping calcareous plates along their backs. Like the armadillo, they can curl up in self-protection should they become dislodged from the substrate. Many make their living in tide pools, grazing algae off rock surfaces with their rasping radulae. Blue shells are as rare as blue foods, giving these mesmerizing turquoise chitons, as well as indigo-hued mussels, something in common with the blueberry.

Opposite: **Giant clam. Philippines.** *Following pages:* **Giant clam. Thailand.** The largest living bivalves, giant clams can grow more than four feet long. They feed on nutrients manufactured by algae that live symbiotically in their mantle tissues; the algae also produce an enzyme that catalyzes mineralization of the shell, which is how giant clams become giant. The algae are in turn protected by the clam tissue and shell from grazing herbivores. Together they live in shallow-water coral-reef environments, with plenty of sunlight to fuel the algae's photosynthesis. It is all too easy to see why collectors are decimating populations of these flamboyantly frilled clams.

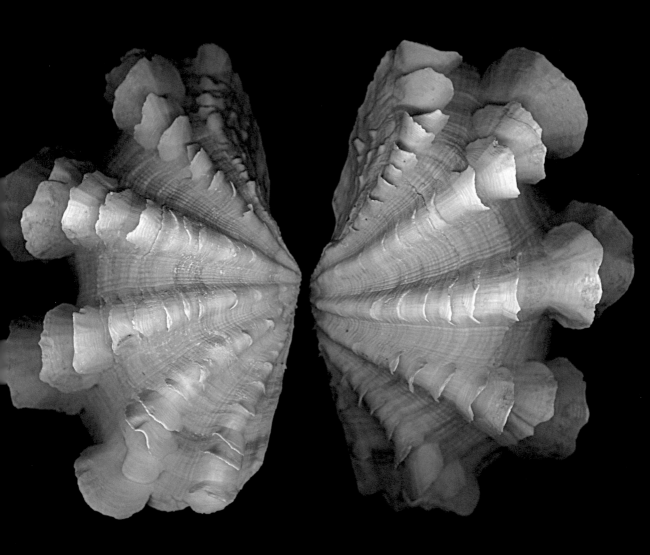

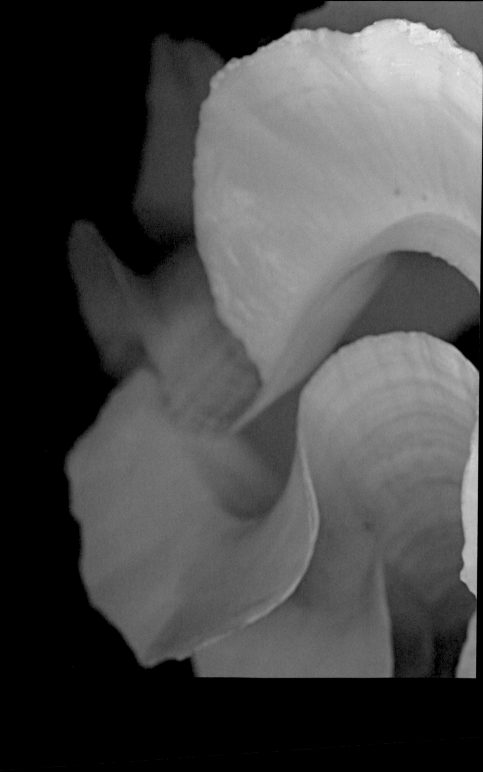

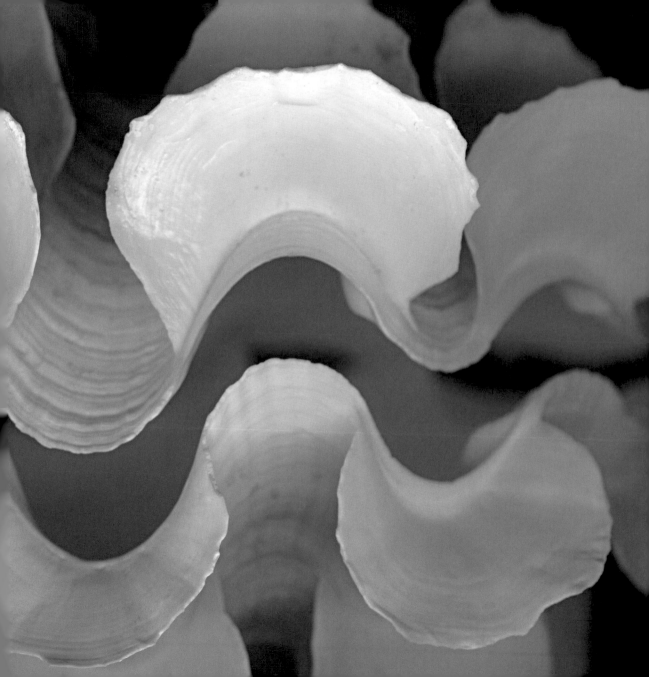

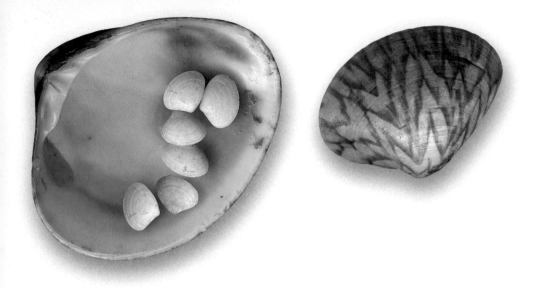

Above: **Brooding clam. Mexico.** *Opposite:* **Brachiopods. Southern California.**
Most underwater parents never know their offspring; some even devour them.
By contrast, the diminutive clam *Transennella*, above, broods a small number of
babies inside the safety of its shell, investing considerable time and energy to
ensure that at least a few will survive the larval stage and crawl away. A very
different reproductive strategy prevails for most larger marine invertebrates:
Females and males broadcast thousands of eggs or sperm into the sea during
free-spawning events; at least some of these gametes will escape being eaten
to find each other, fertilize, and develop. One that succeeded is the juvenile
brachiopod *Terebratalia*, opposite, which as a larva settled permanently on the
shell of an adult.

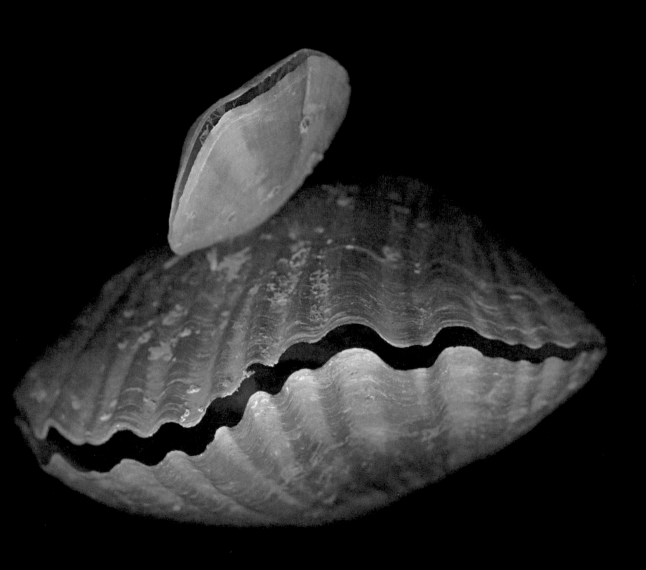

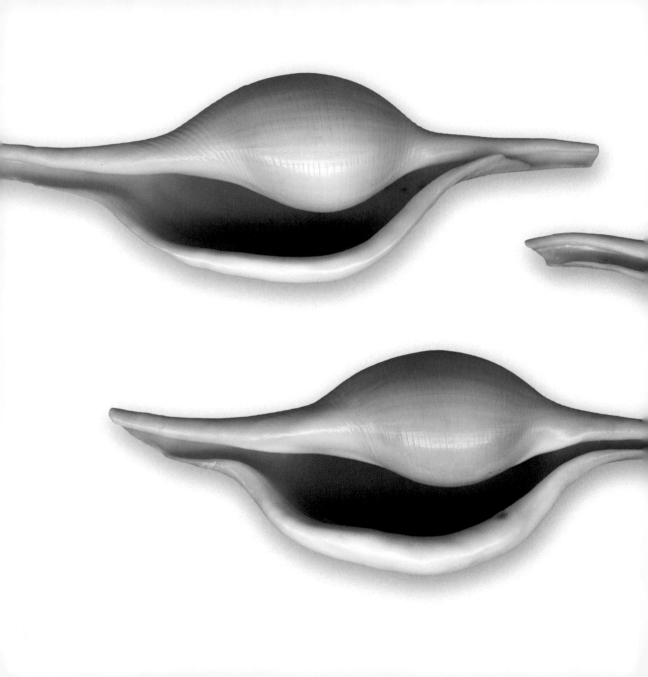

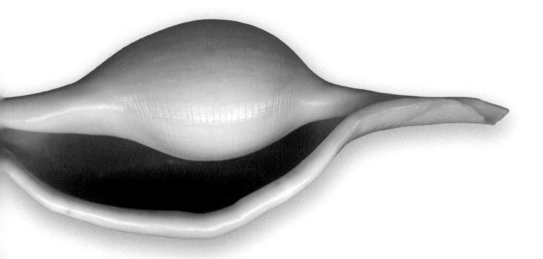

Ovulid snails. Japan. What at first might appear to be a flock of geese in flight is a cluster of sleek, spindle-shaped snails called simnias or false cowries. In life, the shell exterior is completely covered by large, often brightly colored flaps of mantle tissue—as are genuine cowries—which gives it a fine polish.

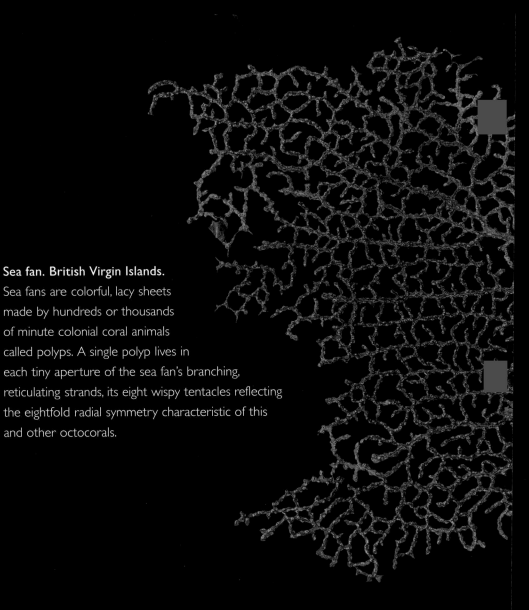

Sea fan. British Virgin Islands.
Sea fans are colorful, lacy sheets
made by hundreds or thousands
of minute colonial coral animals
called polyps. A single polyp lives in
each tiny aperture of the sea fan's branching,
reticulating strands, its eight wispy tentacles reflecting
the eightfold radial symmetry characteristic of this
and other octocorals.

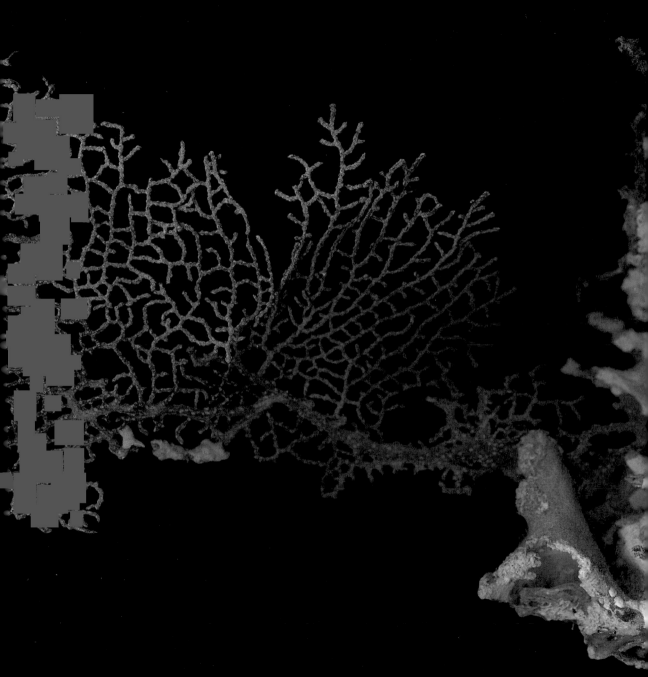

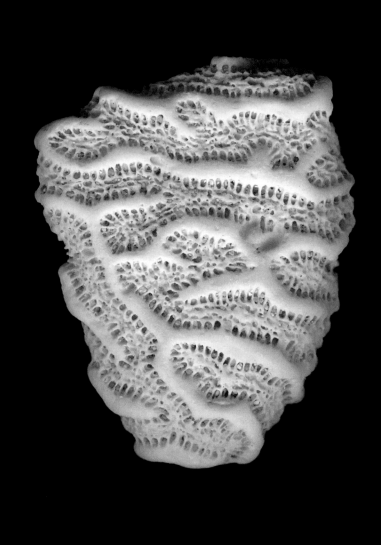

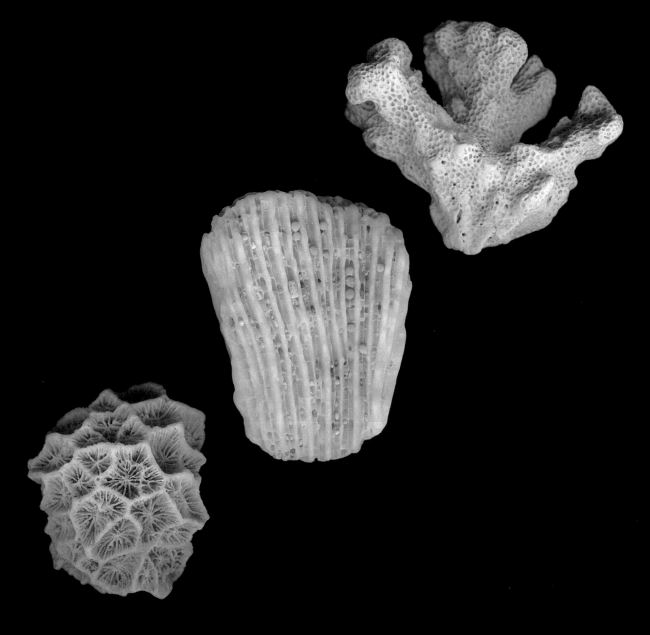

Preceding pages: **Colonial scleractinian corals. Bali and Honduras.** "Soft" corals like sea fans are made from a flexible protein, but "stony" scleractinian corals mineralize a rigid skeleton of calcium carbonate. In tropical waters they accumulate in massive, fast-growing colonies to form reefs.

Opposite: **Organ-pipe coral. Bali.** One of the few octocorals that create calcium carbonate skeletons, the aptly named organ-pipe coral produces fragile pink or reddish orange tubes, each one housing a tiny polyp. The colony mineralizes thin horizontal platforms that bind the long tubes together, giving the colony some stability and strength in life. Chunks can break off easily after death, revealing a cross section that looks like a handful of soda straws.

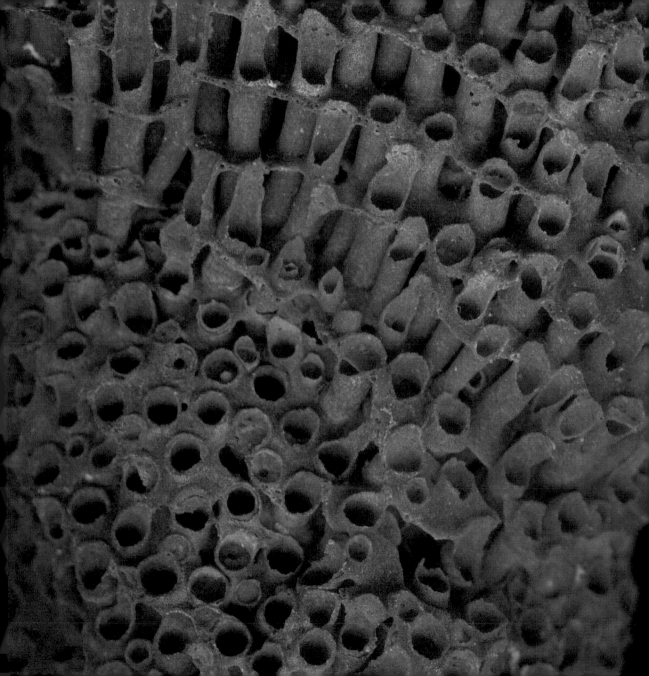

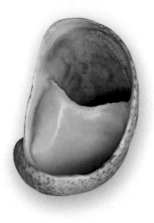
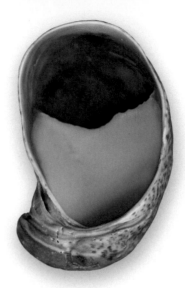

Slipper limpets. Massachusetts. Cuddled together like a covey of quails, these muted limpet shells look as unremarkable as the old slippers for which they're named. But as their species name, *Crepidula fornicata,* hints, slipper limpets lead an eventful love life. They are sequential hermaphrodites; born male, they become permanently female in midlife. They live in vertical stacks, with younger, smaller males settling atop progressively older and larger males-turned-females. The males extend their long reproductive organs well below in the stack, inserting them under the females' shells to inseminate them. This lifestyle seems to be as successful as it is unconventional, as slipper limpets are common in intertidal environments.

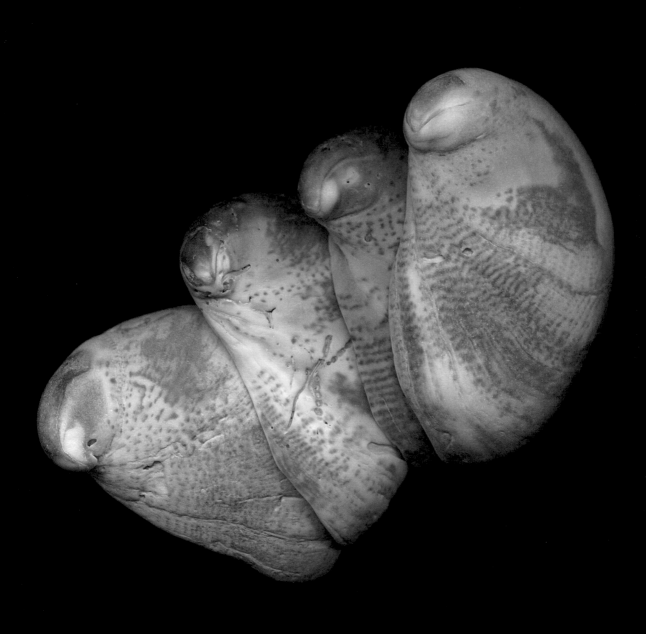

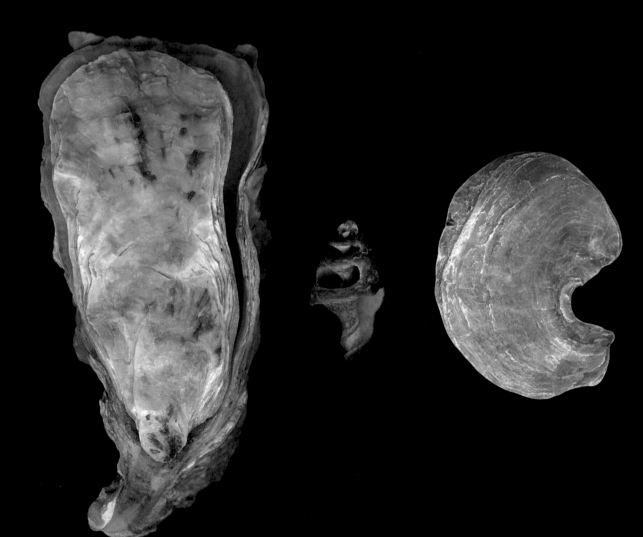

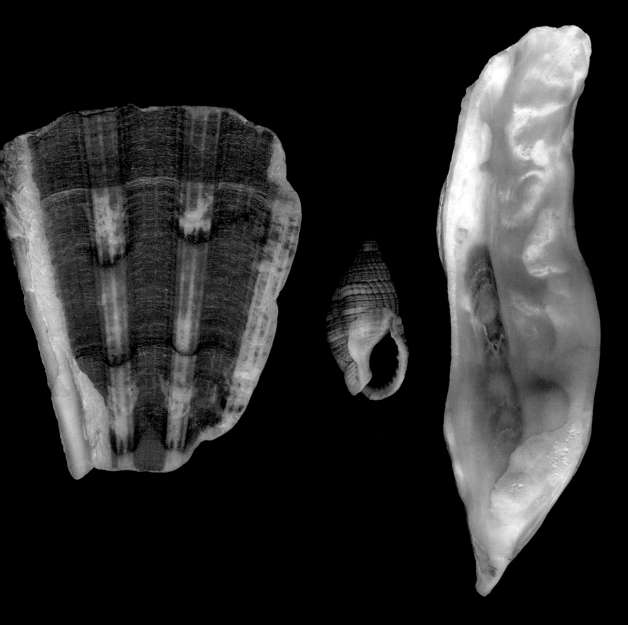

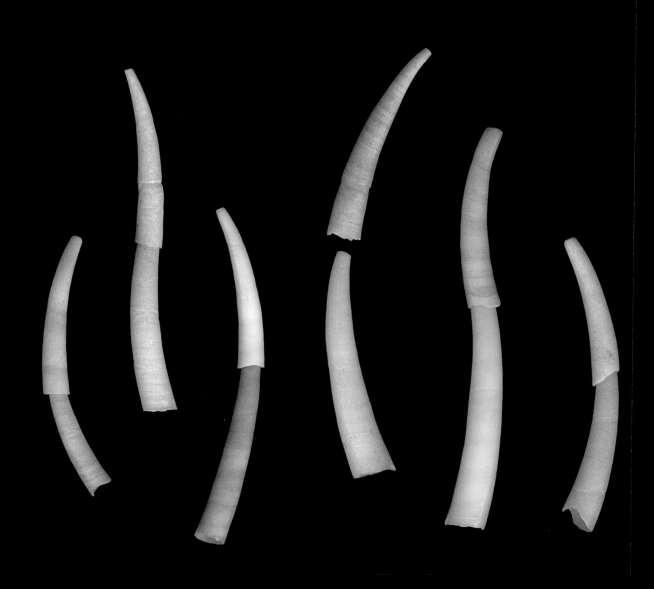

Elephant tusk shells. Sardinia and Southern California. Scaphopods, a class of mollusc, make elegantly simple tusk-shaped shells—hollow, slightly curved tubes that are open at both ends. The creatures live out their lives with the wide end of the shell burrowed in the sand or mud; it houses the head, foot, and sticky tentacles that extend to capture single-celled prey. The tapered end rises almost vertically from the sediment like a tiny straw, allowing oxygenated water to be pulled in from above the sea floor.

Piddock clams. Northern California. Each of a piddock's two valves has a smooth and a rough end; the rough end helps the clam bore its home. While just a larva, the piddock settles into small crevices in hard rock. The growing baby rotates itself on the rock surface like a drill, using the abrasive ridges of the bottom half of its shell to grind out a teardrop-shaped borehole, in which it lives for the dozen or so years of its life. As it grows, it continually makes a larger rock home that fits snugly around it.

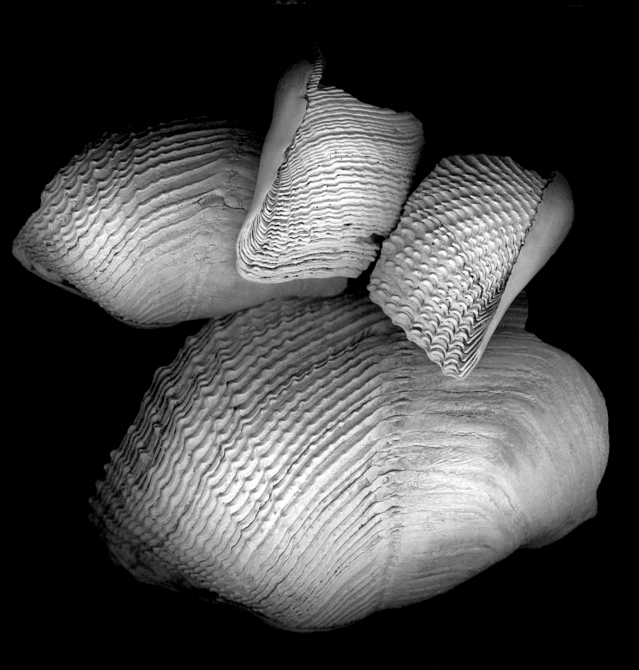

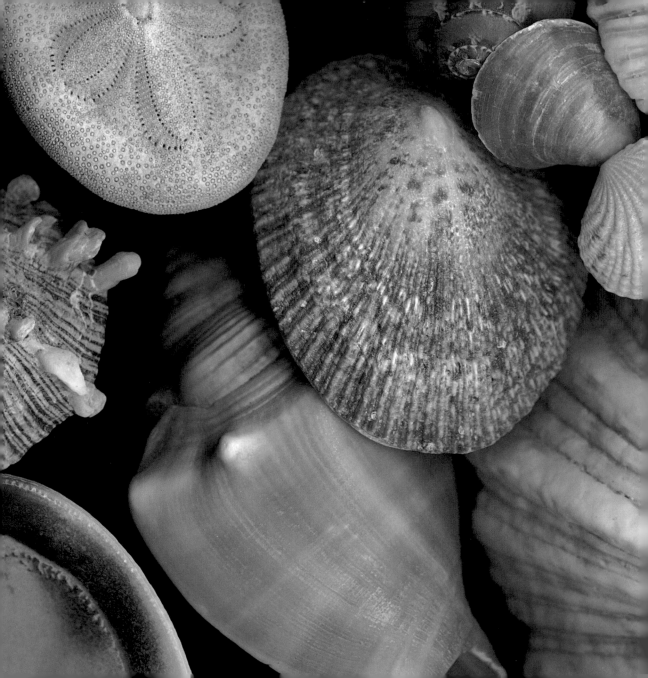

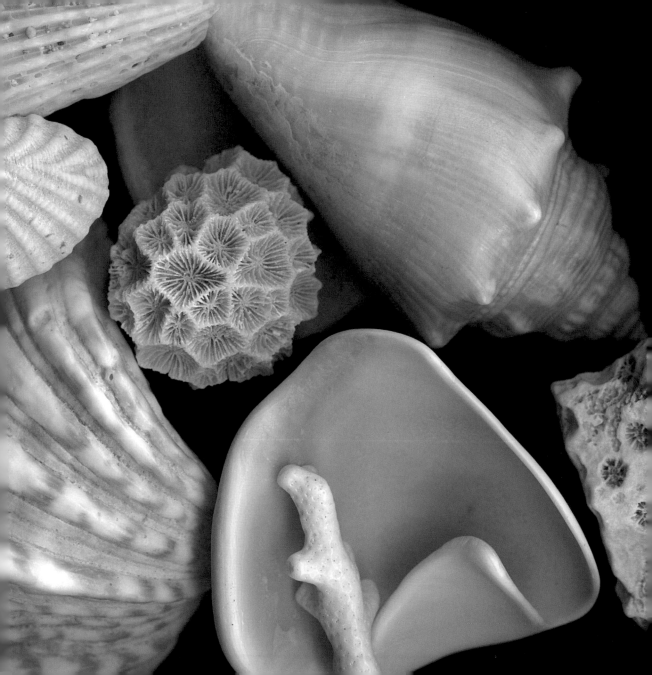

Seashell fossils (Pleistocene). Louisiana. These diminutive fossil shells, less than a million years old, were washed from a lump of Louisiana delta mud the size of a tea bag. Shells accumulated in that muddy marine environment over many thousands of years, so diversity is high: Included in the cluster are various clams and snails, whole and in pieces, curved white annelid worm tubes, a tusk shell, and "moss animals" (bryozoans) that look like perforated buttons. Shell color has leached away over the ages, but the nacre is still iridescent. Neat, circular drill holes provide fossil evidence of tiny predators.

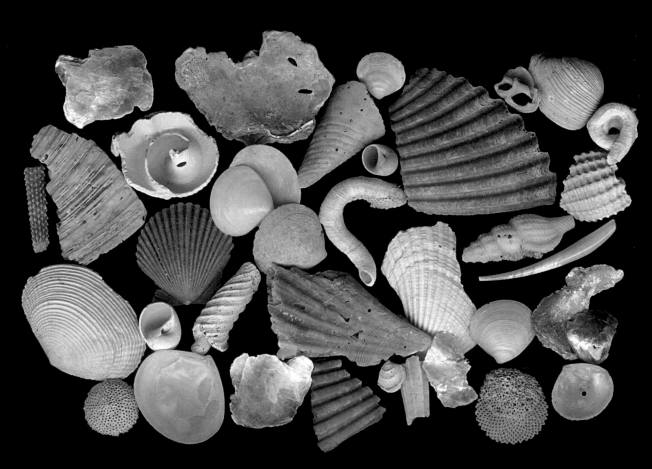

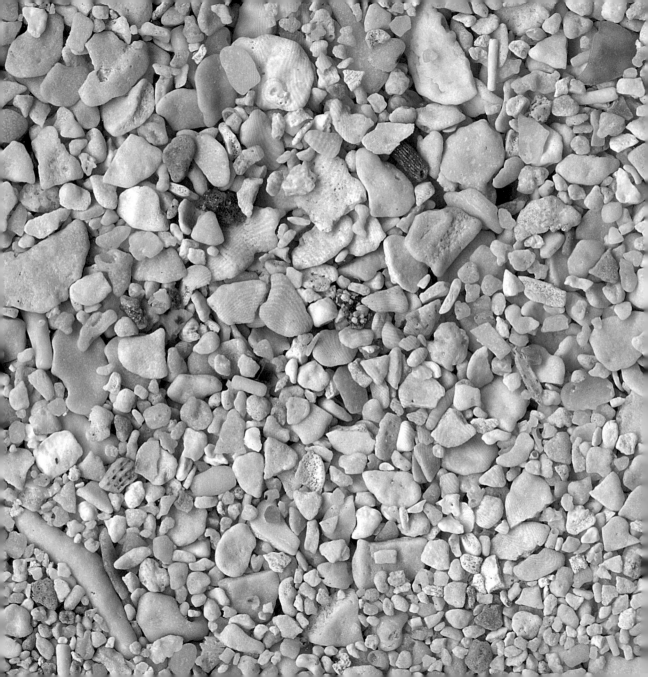

Carbonate sand. Belize. The sand of beaches in cold and temperate climates is formed of hard minerals eroded from rocks and washed to the ocean by rivers and streams; by contrast, tropical beach sand is often composed of the seashells that are so abundant in warm waters. Nearing the end of a long life, bits of shells—fragmented, eroded, weathered, and worn—form a beautiful carbonate sand (here magnified about ten times) that is clean, white, and smooth underfoot.

artist's note

My grandmother's seashell collection fills me with great joy. It makes me think of her walking slowly on the beach, where the calm found in the confluence of sand and tide can be pocketed in the form of a bit of calcium carbonate.

Seashells are powerful reminders—of people and places, of summer, of toes in the sand. Better than any snapshot, they recall that long-ago trip to Bali, the Caribbean, or Nantucket. Their symmetries, spirals, and patterns are fascinating to gaze upon, their dialectical strength and fragility awesome to ponder; they provoke so many questions about how they were made.

Working with Sandy Carlson to answer some of those questions has been a delight. Her knowledge about the underwater world that coexists with our terrestrial one is exhaustive. A walk on the beach with her turns into miles of insights about a mollusc's behavior, all sparked by a shard of shell. Together we have sought to reveal shells' mysteries by marrying keen observation with scientific explanation.

My job as photographer is simply to look closely. In doing so, I found magnificence in even the plainest of seashells. Instead of a camera, I use a flatbed scanner, which splendidly captured the shells' detail, nuance, and volume. It elicited a strength of

form that was intoxicating to work with on the monitor and great fun to translate to the page.

As for *Beach Stones* and *Leaves & Pods,* I amassed the collection pictured here collaboratively. Most of this book's subjects were found at the water's edge. Friends and relatives contributed bowls full of shells and treasure. My aunt's attic yielded my grandmother's shells, which she collected over a lifetime of meandering along the shore of her beloved Pawley's Island, in South Carolina. I also had the privilege of exploring the fossils and shells at the California Academy of Sciences in San Francisco.

I thank my fellow collectors for sharing their shells: Polly Saltonstall, Delphine Eberhart, Lisa Gross, Sandy Goroff, Alan Constant, Alison Mattoon, Mary Swanson, Kari McCabe, Katie Bishop-Manning, Claudia Scharff, Susan Evans and her family, Via Lambros, Janet Macomber, Elizabeth Corbus, and, always, Cathy Iselin. Also, Jean DeMouthe, Bob Van Syoc, Peter Roopnarine, and George Metz at the academy. And I thank my aunt, Judy Cromwell, who so lovingly packed up my grandmother's shells. The spirit of my grandmother, Fannie Brawley, who took great inspiration from and care with all things natural, has been hovering around my studio throughout the making of this book.

JLI

writer's note

To a girl growing up in Minnesota, seashells represented just about the most exotic and attractive natural objects on earth. I can remember collecting shells of lake clams when I was very young and painting them with my watercolors to try to make them look like abalone—real seashells. My fascination with shells and the organisms that create them led me to make a career of learning about the biology, evolution, and fossil record of these wonderful creatures.

I hope this book engenders some of the same fascination among readers. It offers a breathtakingly beautiful and unusual presentation of a wide range of seashells—far beyond the usual conchs and scallops that can be found for sale in any shell shop on any coast. The text attempts to enrich the pure aesthetic joy a seashell can bestow. It provides a sense of how these shells came to be—how they grow, function, and evolve—and brings to light the great diversity and adventures of undersea life. This book may introduce you to the wonder of *Spirula,* tusk shells, ammonites, or brachiopods—my favorite—and, I hope, inspire you to find out more about them.

I thank my family—Steve, Zoe, and Eli—for their support throughout the evolution of this project. I want to thank Dr. Ken Finger (UCMP Berkeley) for lending us a sample of his mudlump fossils, and Tim Wells for sharing his prized *Scutellaster* fossils. I also thank the staff of the California Academy of

Sciences, particularly Dr. Peter Roopnarine, Bob Van Syoc, and Jean DeMouthe, as well as George Metz, for granting access to and assistance with collections for scanning. I thank Nancy Cohen for her editing prowess and Eric Himmel, editor in chief of Abrams, for the vision to produce such a lovely nature series. Most of all, I want to thank Josie Iselin for inviting me to create this book with her. It has been a treasured privilege, a special treat, and a great deal of fun.

SJC

143

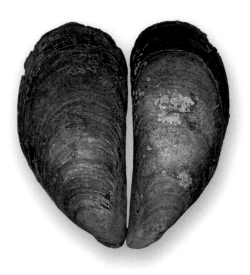

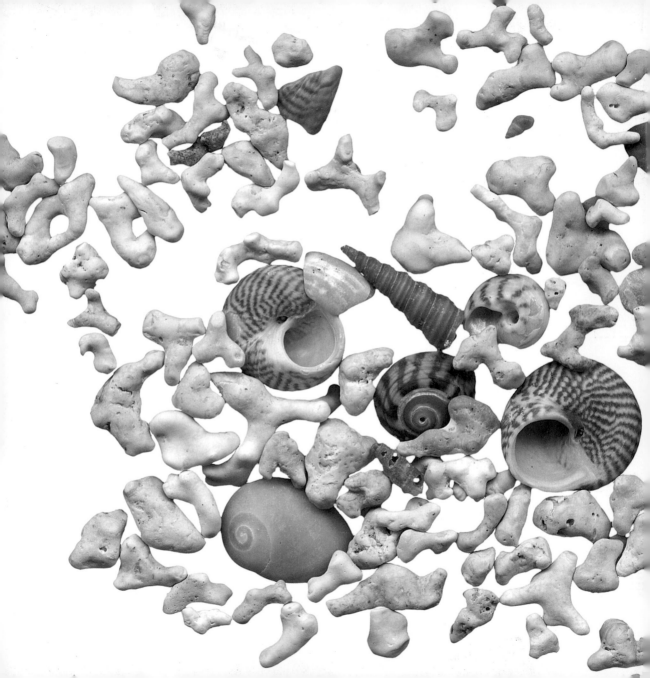